BLANKET
TOSS
UNDER
MIDNIGHT
SUN

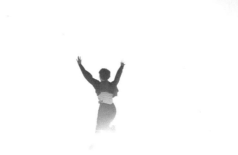

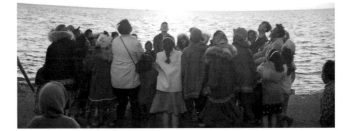

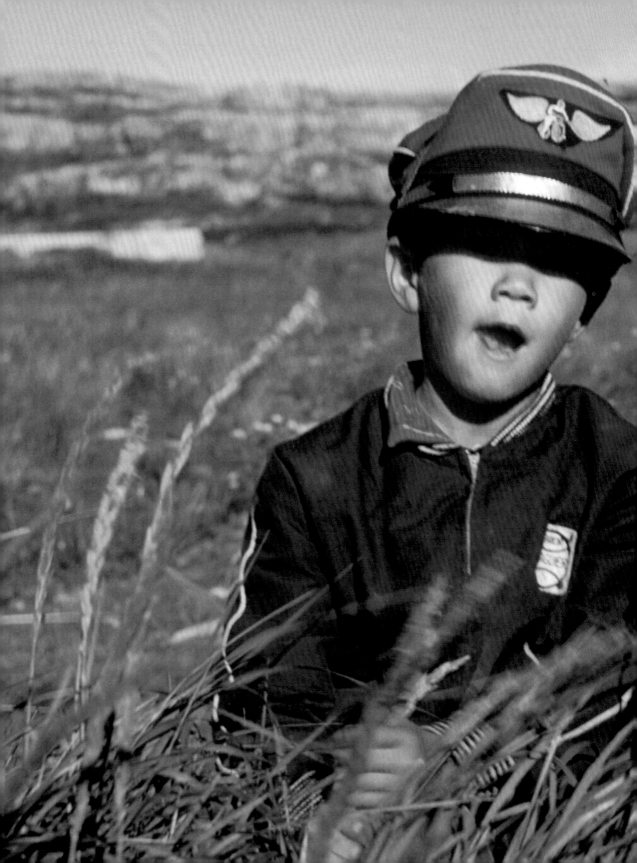

BLANKET TOSS

UNDER

MIDNIGHT SUN

Portraits of Everyday Life in Eight Indigenous Communities

PAUL SEESEQUASIS

ALFRED A. KNOPF CANADA

PUBLISHED BY ALFRED A. KNOPF CANADA

Copyright © 2019 Paul Seesequasis

www.penguinrandomhouse.ca

Alfred A. Knopf Canada and colophon are registered trademarks.

Pages 171–178 constitute a continuation of the copyright page.

Library and Archives Canada Cataloguing in Publication

Seesequasis, Paul, author
 Blanket toss under midnight sun / Paul Seesequasis.

Issued in print and electronic formats.
ISBN 978-0-7352-7331-3
eBook ISBN 978-0-7352-7332-0

1. Native peoples–Canada. 2. Native peoples–Canada–Pictorial works. 3. Native peoples–Canada–
History–20th century. 4. Native peoples–Canada–History–20th century–Pictorial works. 5. Native
peoples–Canada–Social life and customs–20th century. 6. Native peoples–Canada–Social life and
customs–20th century–Pictorial works. 7. Native peoples–Canada–Social conditions–20th century.
8. Native peoples–Canada–Social conditions–20th century–Pictorial works.

I. Title.

E78.C2S384 2019 971.004'9700904 C2017-907366-4
C2017-907367-2

Cover image: Wilfred Doucette
Book design: Jennifer Lum
Printed and bound in China

10 9 8 7 6 5 4 3 2 1

Penguin
Random House
KNOPF CANADA

For Coltrane and Suriya

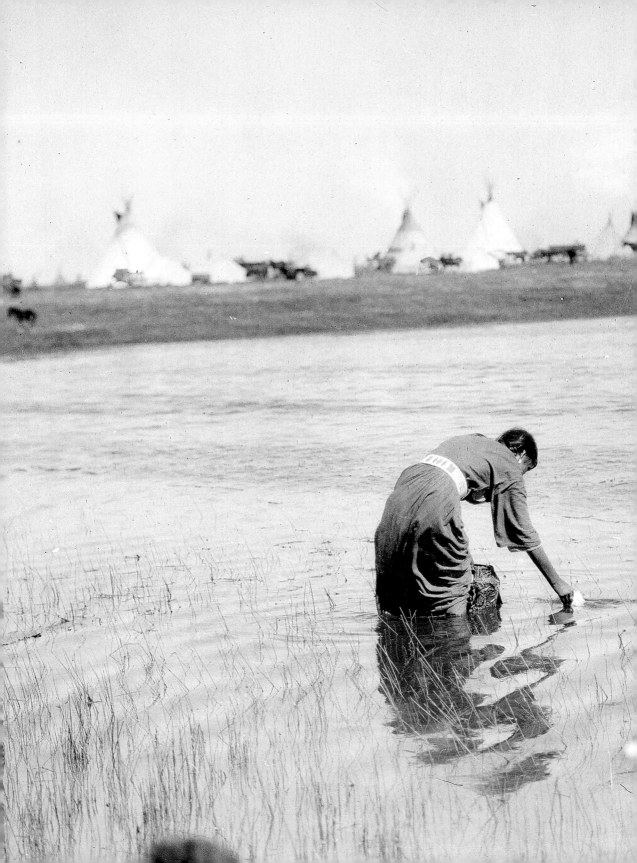

Contents

"I am telling the true things I know. I am not adding anything
and I am not holding anything back."
—PETER PITSEOLAK, *People From Our Side*

"Photographs are a way of imprisoning reality . . . One can't possess reality,
one can possess images—one can't possess the present but one can possess the past."
—SUSAN SONTAG, *On Photography*

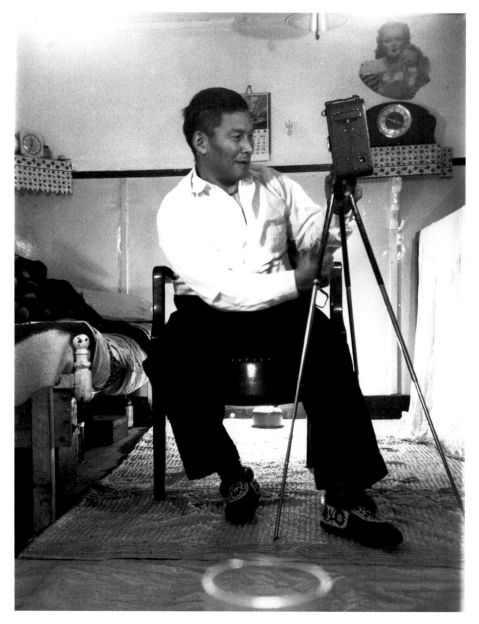

Peter Pitseolak (Inuk) with his 2222 camera, Keatuk, Baffin Island, c. 1947. (**Aggeok Pitseolak**)

Introduction

"A photo more than a painting may change its meaning according to who is looking at it."
—JOHN BERGER, *Keeping a Rendezvous*

All photographs represent moments in time, but at their best they are also able to inspire something intangible—an emotion, an empathetic response, occasionally a realization. Then one recognizes that there are stories within the image. Often these stories are lost, but something can be gleaned and the photograph can go further.

One might call *Blanket Toss Under Midnight Sun* a collection of Indigenous photographs. To be more precise, it is a book of photographs of Indigenous peoples, taken for the most part by non-Indigenous photographers, primarily in what is now Canada. These were not just any photographers but those who, through various circumstances, became embedded in a community long enough for their lens to not be as obtrusive as a tourist's, for the camera to be accepted enough that what is framed is not staged or phony. Alongside these photos appear those of the first generation of Indigenous photographers, among them Peter Pitseolak and George Johnston, who in the mid-twentieth century became pioneers within Indigenous photography.

Somewhat ironically, as it brings to life images taken decades ago, *Blanket Toss Under Midnight Sun* began in a most transitory and temporary medium: social media. Over three years ago, my mother, a residential school survivor, remarked that she was "tired of hearing just negative things about those times" and that "there had been positive and strong things in Indigenous communities *then*." I began to

search through archives, seeking not residential school photos or other images of colonization but images reflecting a different reality, that of integrity, strength, resourcefulness, hard work, family and play. And I found them.

Over time I began to recognize the work of specific photographers and became familiar with certain communities at particular moments. I was able to identify which archives had digitized their photographic collections, which museums and libraries held the work of photographers I was curious about, and which photographers, still alive, had their works online.

When I began to post these archival photographs online, I was surprised by the response. I had expected some people to "follow" and "like" the photos, but I had not counted on the comments. Many viewers had never seen the photographs before, but posted to say, "That's my grandmother!" or "That's me, forty-two years ago!" This act of naming brought another layer to the photographs: reclamation. It was a rewarding exchange and every day brought something new. I was aware, of course, of Project Naming, a collaborative effort between Library and Archives Canada and Nunavut Sivuniksavut, which offers a special college programme based in Ottawa, serving Inuit youth, to name people from archival photos, so it was another positive step to be able to share and collaborate with Project Naming as the project continued.

History has always interested me, but I am neither a trained historian nor an archivist, so I encountered much learning as I went along. I stumbled, occasionally made assumptions that were in error, and was grateful when I was corrected. I also learned that archival notes are not always accurate in name, location or cultural identity. There were lessons to be repeated like a mantra: *Never assume.* Worse, *Never add your assumptions to the captions. Reprint the archival captions as they are, but expect, in many cases, they will be wrong or inaccurate. Hope that in the seeing, someone out there will recognize a face, a hill, a building.* Finally, *Expect the unexpected.*

When an impression of the past is taken, it is "possessed," but it cannot be restored, nor can the entirety of its secrets be revealed. The stories that accompany the photographs in this book come from lived memory, conducted through many interviews, or researched over countless hours in the archives. Still, they tell only part of the story. They afford a glimpse into the past and a sense of how things

were, but not a fulfillment. As historian Mary Scriver remarked, referring to questions she has posed to Blackfeet elders, the answer is often "could be." So many of the stories here *could be*. That does not delegitimize memory or historical accounts, but it points to a certain wisdom that the story is only a small part of the picture and the picture itself only a small part of the story.

When Edward S. Curtis travelled the West and Northwest, taking photos of "Native Americans," he was doing so with the steadfast belief that "Indians" and their way of life were disappearing. He felt himself a chronicler of a dying race. He was seeking something that Anishinaabe philosopher and writer Gerald Vizenor would call a "terminal creed," a form of stasis. Curtis's was an outsider's gaze fraught with the perils of romanticization. He saw the adaptation to modernity as a loss of traditional life. Curtis carried a suitcase of traditional props so that things *could be* the way he expected them to be.

Of course, as we know, Curtis was wrong in intimating that Indigenous peoples and their way of life were dying. But he was correct that customs were changing, and ways of hunting, fishing and making things by hand were in flux. However, he failed to grasp that Indigenous ways of being have always been about change and adaptation. Indigenous life was evolving, as it always had and always will.

The photographs in this volume are varied in period, nation and landscape. Beyond just "how things were," they reveal how things were changing. In curating these eighty-plus photos out of hundreds of possible choices, I've focused on roughly a dozen photographers who spent reasonable time in the communities, and who, for the most part, had what one could call "real relations" with their subject matter.

How we view the photograph is dependent on where we are coming from. Are we looking with an outsider's curious gaze? An anthropological approach to study the "other"? Or a more intimate reconnection to past family, kin and lifestyle? Also within the framing of the photograph is our individual approach to *Indigeneity*, a word combining *Indigenous* and *identity*. "Well, what is indigenous identity? Who defines it: a government, a group of people, an authoritative individual?" writes Tlakatekatl.[1] The photographs in this book are Indigenous in that they portray First Nations, Metis and Inuit communities, but what else binds them together? A relationship to land? A shared sense of community or tradition? It is easy to

generalize that these are individual people at a given moment in time, that these places and peoples are geographically and culturally diverse, and that the differences are as profound as the similarities. But generalizations obscure reality.

Most if not all of the photographers in this collection were aware that their photos were for future generations to look back upon. But their motivations differed. Walter McClintock, for example, was an "outsider," a white person with a fascination for Blackfeet culture and lifestyle but only insofar as it fit into his frame of a disappearing way of life. He was not particularly interested in how contemporary Blackfeet were living outside the summer camps he photographed. Yet he had a sensitive eye and took moving photos of women and children, at a time when most male photographers were more interested in "masculine" subjects, such as hunting or war. Peter Pitseolak, by contrast, was an Inuit "insider" and was motivated to capture the day-to-day life of Inuit for future generations—how things were, how people hunted, fished and built shelters. Living in the Arctic, and with the eventual help of his partner, Aggeok Pitseolak, he was able to overcome the challenges of producing pictures far from any town or darkroom. Pitseolak was not concerned with the outside gaze; McClintock took his photos specifically *for* the outside gaze.

Rosemary Eaton came to Canada as an English immigrant. Perhaps this outsider identity, in small part, explains her fascination with both First Nations and Inuit peoples and her ability to achieve a disarming intimacy in many of her photos. As a woman and photojournalist, she was also, in her own way, removing barriers in a male-dominated profession.

Long before the advent of smartphones and social media, we used images to define ourselves and represent how we wish others to see us. The most recent photos in this book date from the 1970s; when most of these photos were taken, the camera was a more time-consuming novelty, not a small computer you carried in your pocket or purse. Only in George Legrady's photographs of Cree communities in the James Bay area do you encounter people walking around with Polaroid cameras. The Polaroid provided a solution to the problem of developing film by sending it south and waiting for weeks, if not months, to get your pictures back. Some Indigenous photographers, including George Johnston in the Yukon and Pitseolak in the Arctic, built their own makeshift darkrooms.

The photographs in this book are from digitized collections of archives, libraries and museums, as well as the private collections of photographers. In posting these and hundreds of other photos over a three-year period, I gradually built a rapport with "followers," adding an essential aspect to the project. People from the communities, many of whom had not seen the photographs, were able to identify family members, relatives, friends, occasionally themselves. A further dialogue began to unearth stories, providing a narrative that went beyond the photo, giving context and history and often leading to other, related photos. It would have been near impossible to research and gather these stories without the Internet. Even if one had an unlimited budget to travel to each of these regions, you would not know where to begin, whom to talk to, who was still alive and who was able to give context; social media opened up that channel.

"Honouring the resilience, resourcefulness and determination of generations. No, we are not moving anywhere." These two lines appeared on the tweet pinned to the top of my page. Three years and hundreds of photos later, it still feels that in many ways I am just scratching the surface. There are photographs out there waiting to be discovered, shared and reconnected to lived memory. This book contains only a sampling, focused on specific archival fonds and geographical regions, mostly in Canada. A representational snapshot of Indigenous life from the early 1900s to the 1970s, from coast to coast to coast, would be beyond the scope of a single book. The focus narrows even further, following the work of specific photographers and photojournalists, and certain individuals who are remembered and who left an impact. Those photos going further back are dependent on recorded history.

The introductions to each of the eight chapters will, I hope, provide useful background to the reader. The narratives and captions provide context, but the photos speak for themselves.

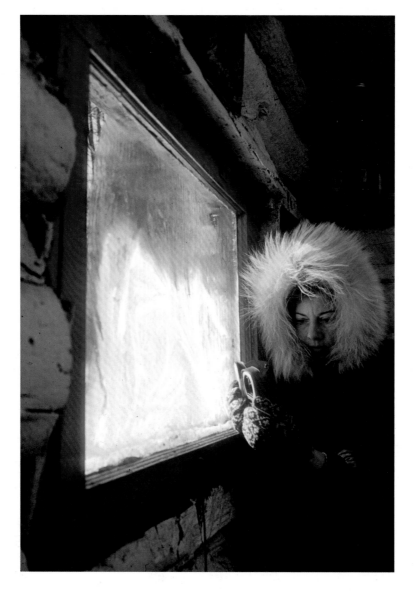

Above: Rosemary Eaton in Gatineau Park, Quebec.
(Rosemary Eaton)

Opposite: James Jerome (Gwich'in),
likely in Inuvik, c. 1977–79.
(James Jerome)

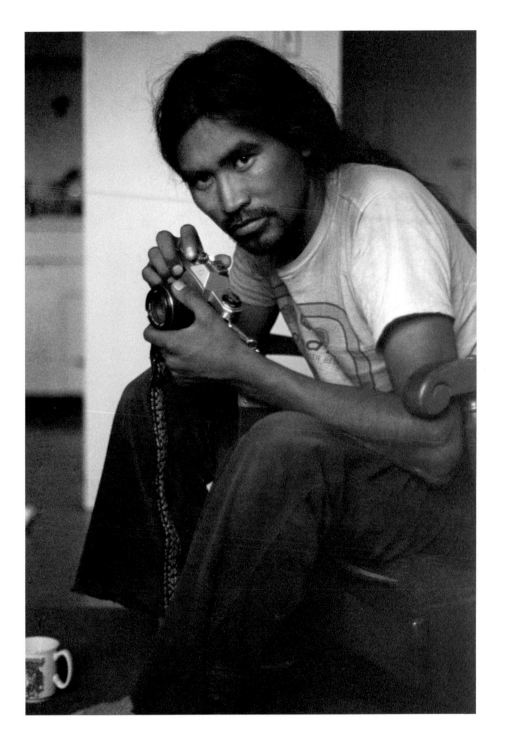

LIGHT EMERGING

CAPE DORSET AND NUNAVIK

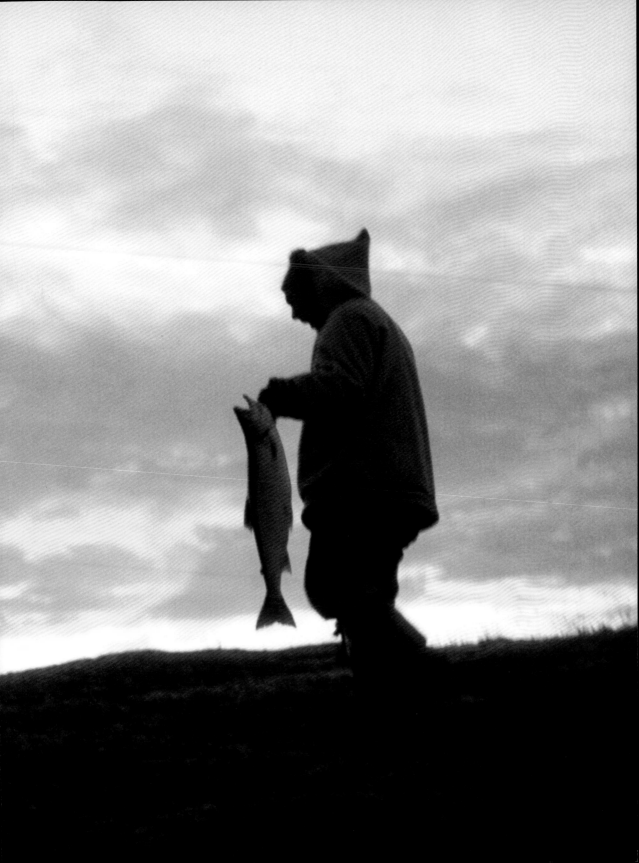

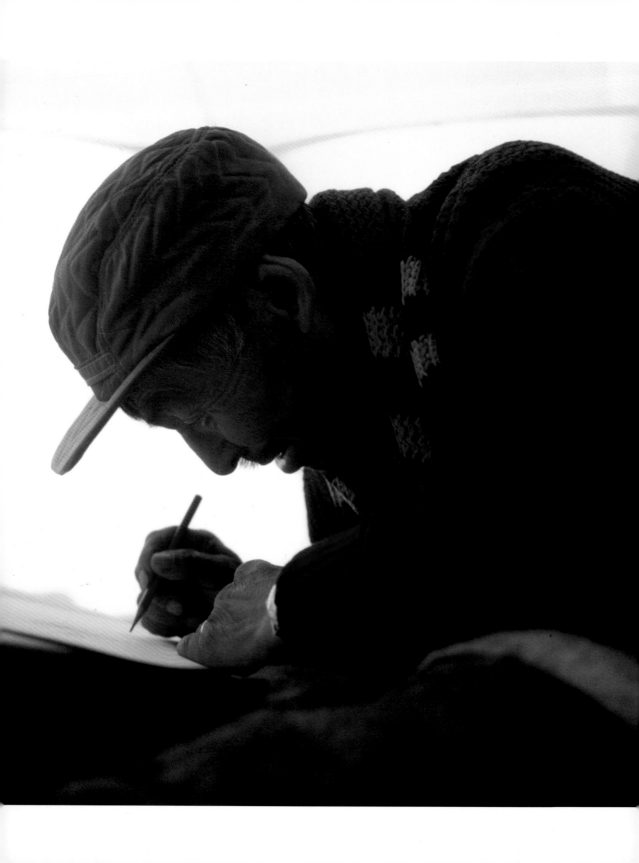

CAPE DORSET (KINNGAIT)

Like so many other land formations in what is now Canada, Dorset Island, and the surrounding area, was not named for its original inhabitants, nor the flora and fauna, nor the terrain.

Instead it was named after the Earl of Dorset, Edward Sackville, a prominent figure at the court of Charles I of England. Dorset, of course, would never set foot on the North American continent, let alone Dorset Island. The peninsula that Dorset Island lies off of was, similarly, named after Captain Luke Foxe, an early incarnation of the many English explorers who came, in vain, in search of the Northwest Passage. That the local Inuit called the place Sikusiilaq, after the sea water in the area that remained ice-free all winter, was, of course, ignored.

Dorset Island is marked by a 243-metre-high mountain, or "cape," that is part of the Kinngait range, a translation of the Inuktitut word for "mountains." Peaks and escarpments define this beautiful landscape, which also happens to be home to some of the oldest rocks in the world.

For more than 4,500 years, nomadic groups of Indigenous peoples have visited and camped among the hills surrounding what is now Cape Dorset (Kinngait). The waters supplied abundant seal and whales, the land caribou and other game, depending upon the season. The original Dorset people inhabited the area around the present-day town of Cape Dorset from, it is estimated, about 800 BC to AD 1300.

This culture apparently adapted and thrived during a time when the climate became much colder than that experienced by the people of the pre-Dorset culture. As a result, the Dorset people became extremely skilled at hunting on frozen sea ice, and they are presumed to be the first Arctic peoples to build iglus. The climate, however, warmed again around AD 800, and the Dorset way of life was destabilized by a shorter winter hunting season.

The direct ancestors of today's Inuit, the Thule peoples, arrived in the area around AD 1000, and the stone foundations of Thule dwellings remain evident throughout the region today. Thule culture centred on the hunt, in this case of sea mammals such as seal, walrus and narwhal. These creatures were hunted with harpoons in boats made from animal hides. We also know that, by this time, dog teams and dogsleds were a common means of land transport, enabling Thule people to travel farther in a much shorter period of time than before.

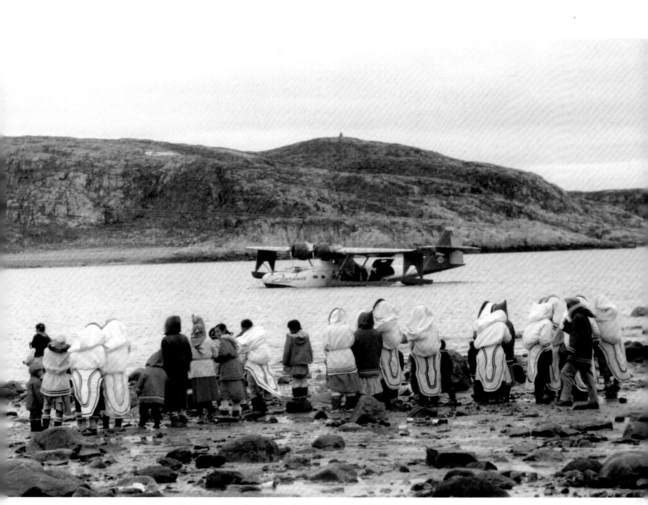

Waiting on the float plane, Cape Dorset, c. 1960. (**Rosemary Eaton**)

"I've always thought of the Cape Dorset people
as being a bit larger than life; they sort of lived life on a grand canvas."
–JOHN HOUSTON

Artists (left to right): Eegyvudluk Pootoogook, Iyola Kingwatsiak and
Lukta Qiatsuk (Inuit), Cape Dorset, c. 1960. (**Rosemary Eaton**)

The region started to see visitors in the form of whalers and missionaries beginning in the mid-nineteenth century, with the Hudson's Bay Company establishing a trading outpost in Cape Dorset in 1913. Soon, a small village began to grow around the post, leading to an influx of goods and technologies into the region from the South.

The mid-twentieth century was a period of great change for the small hunting camps in and around Cape Dorset, as it was for the whole Arctic region. A worsening scarcity of caribou increased the ever-present threat of starvation, and Canadian federal government policies, developed by bureaucrats in faraway Ottawa, "encouraged" many Inuit families to decide to settle permanently in Cape Dorset. Between the late 1930s and early 1950s, as settlement increased, a school and several Christian missions were established there. As we will see later, Peter Pitseolak, the great Inuit photojournalist, was a witness to this transition and was inspired to record it on film.

The photographs in this chapter capture the Cape Dorset community at this changing time. The photographs are by Rosemary Eaton (née Gilliat) (1919–2004), who spent an extended period in the community around 1959–60. Her stay there coincided with the burgeoning Inuit arts scene, the establishment of the West Baffin Eskimo Co-operative, and the establishment of the first print shop in 1958. Cape Dorset was transformed from a small seaside government post into the birthplace of the global phenomenon of Inuit art and a generation of Inuit artists who, learning their craft with new materials, were destined to become legends. That moment, and the people involved, was forever captured by the sensitive lens of Rosemary Eaton.

Outside West Baffin Eskimo Co-operative,
1961. (Ryan Terrence)

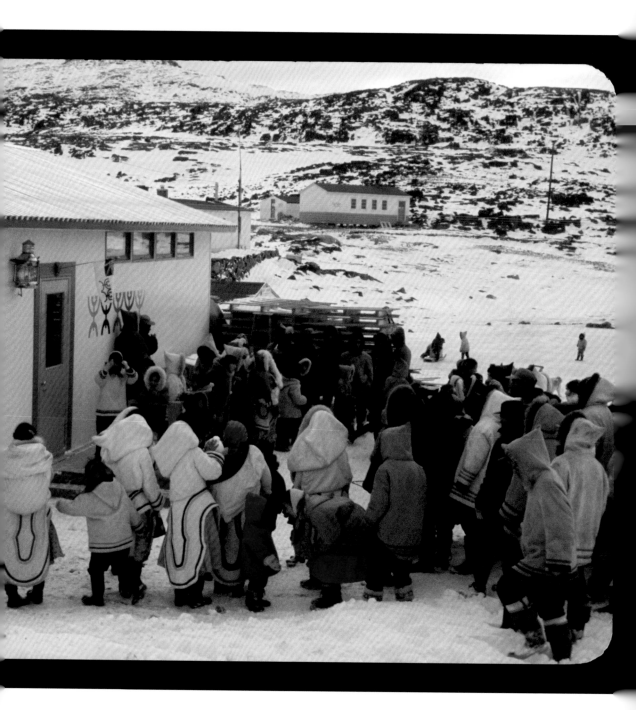

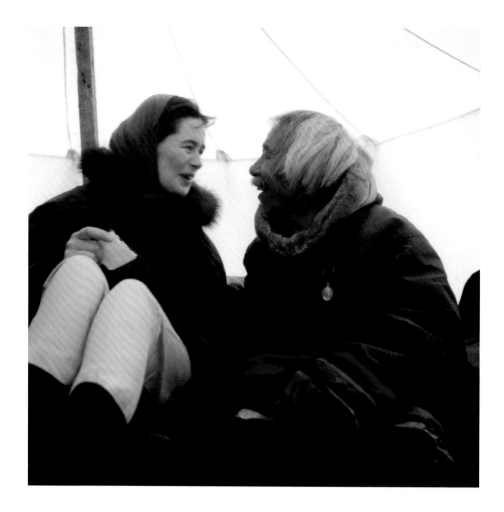

Alma Houston and Andrew Kingwatsiak,
Cape Dorset, 1960. (**Rosemary Eaton**)

WHEN THE ARTIST AND WRITER JAMES HOUSTON (1921–2005) came to Cape Dorset and met Inuit artist Kananginak Pootoogook (1935–2010) in the fall of 1957, neither man could have guessed what would follow, much less the eventual international impact of the artists of Cape Dorset. Serving as an area administrator in the late 1940s and 1950s, Houston was contracted by the federal government to promote Inuit art in the region. In writing this chapter, I interviewed James Houston's son, John, who was a young boy at the time of Rosemary's visit, and who has spent his life writing about, filming and promoting Inuit artists. John was brought up in Cape Dorset, learning Inuktitut from local elders and artists including Pootoogook, Andrew Kingwatsiak (dates unknown) and Kenojuak Ashevak (1927–2013). His memory is of a young photographer named Rosemary, just "hanging around."

The photograph is of the late Alma Houston (1926–97) and Andrew King-watsiak. Kingwatsiak was the father of Iyola Kingwatsiak (1933–2000), one of the original printmakers and a great stone block cutter, as well as a renowned sculptor. It's 1960 in Cape Dorset, and Alma Houston and her then husband, James Houston, have recently been instrumental in setting up the West Baffin Eskimo Co-operative. It will become the gestation lab for what is now internationally recognized as contemporary Inuit art. Kingwatsiak had become a cherished friend of Alma, and this is evident in their body language. It is a moment of love, respect and mutual admiration, captured by Eaton.

Perhaps it is also a moment of fond farewell, as Alma Houston will soon be leaving for a year in England, and then starting a life in Ottawa. According to John Houston, Alma's son, she thought the world of Kingwatsiak, believing him to be a wise man, what today we would call an elder. At this stage of his life, King-watsiak was a bit crippled and walked with a stick. In the long winter months, he was able to move around with a little dogsled that was pulled by a single big, strong dog. "I can see them moving along," John recounted, "as I tell you this. Being pulled by this big trusty dog and he would have his walking stick in his hand and he would pull up to our house and my mother made some kind of arrangement with him so that, each day after school, I would come home from school and meet Kingwatsiak at our house as he was ushered in."

The young Inuit women who worked in the Houston house would help him up the steps and usher him to the playroom, where he'd take a comfortable chair. Tea and bannock would be served, along with pots of Robertson's raspberry and strawberry conserve. Kingwatsiak would share stories of his life and his ancestors, of living on the land long before there was a Cape Dorset. Though he was only five or six years old at the time, John understood what Kingwatsiak was saying in Inuktitut, and it left a lifelong impression on him. "There was a wonderful patience to that man to take me on. And also speaking of my mother, who saw a tremendous benefit for me to hear him."

Alma Houston saw Kingwatsiak as a wisdom keeper, a bearer of great knowledge. Another photo from the shoot shows Alma helping to pin on the medal Kingwatsiak is wearing. It appears to bear a likeness of King George V and may have been awarded to Kingwatsiak in honour of his saving the lives of a couple of whalers. "If I'm not mistaken," John said, "the medal was given by King George V and he was very proud of it. Justifiably. He used to entertain us. We all made our own fun back in those days and one of the things that Kingwatsiak brought to the party, and people never tired of this, people would say, 'Kingwatsiak, tell us again how you've visited with royalty.' And he's 'Oh yes, yes.' 'Well, how are they, these royal people, and what are they like?' 'Oh well,' he'd say, 'now, a king for example, a king doesn't walk like any regular person, they walk much more like this . . .'" And Kingwatsiak would mimic a royal walk, to the delight of his audience.

In the photograph, Alma is holding a small piece of paper, and John recalled that she was always learning Inuktitut, in which she could converse until her passing in 1997. "If, during that conversation, a word or two would come up inevitably that my mother wouldn't know, she would write those down and then ask him about them."

Alma Houston was only the second non-Inuit woman to cross the entirety of Baffin Island by dog team. The Arctic left an indelible impression on her, as did her time with the "wisdom keeper" himself, Kingwatsiak.

Kenojuak Ashevak (Inuk) drawing,
Cape Dorset, 1960. (**Rosemary Eaton**)

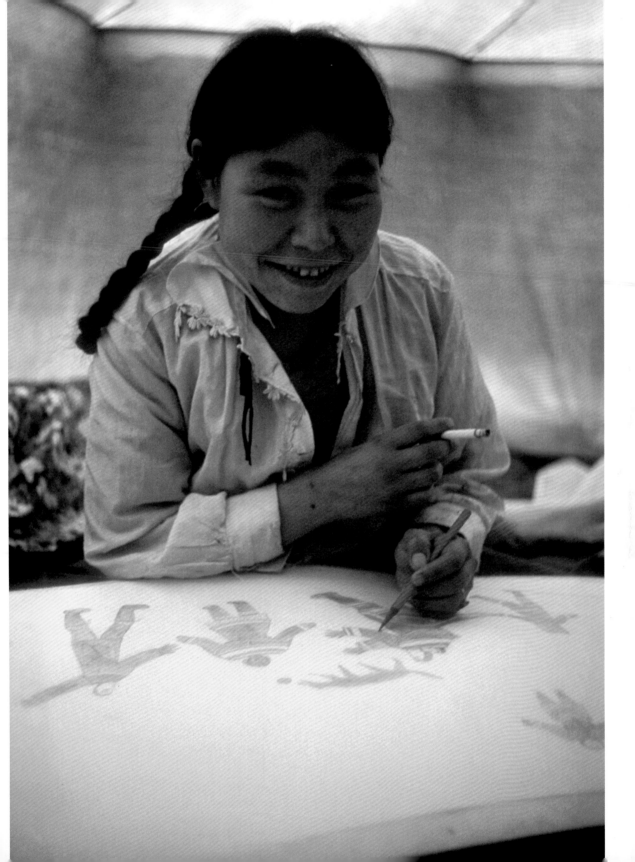

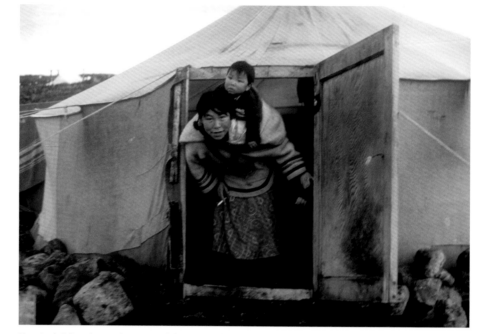

Kenojuak Ashevak, exits her tent with her son, Adamie Ashevak (Inuit), Cape Dorset, 1960. (**Rosemary Eaton**)

KENOJUAK ASHEVAK WAS A PIVOTAL ARTIST in the emerging Inuit arts scene in Cape Dorset. Shown here in 1960, exiting her tent with her son Adamie, her star is already rising quickly. Kenojuak was a powerhouse in the West Baffin Eskimo Co-operative, along with Kananginak Pootoogook. Up until her death in 2013, Kenojuak contributed many prints, and her work sold exceptionally well. She became quite possibly the most famous Inuit artist in the world, known for her prints *Enchanted Owl* and *Return of the Sun*, which appeared on Canadian stamps, and *Red Owl*, which the Royal Canadian Mint included on quarters in 1999. At every annual print collection, from the very beginning, Kenojuak's art was much in demand, providing essential revenue for the emergent co-operative. A founding member and early signatory to its establishment, she was a seminal part of Cape Dorset and the creative culture surrounding it. According to John Houston, "the Inuit [in Kinngait] realized a couple of things right away, and one of them was that the co-op was a kind of an extension of the already timeless Inuit way of being in the world, an extension of Inuit Traditional Knowledge," and the necessity and benefits of working together in the Arctic.

The tent from which she is emerging is typical of the period. The tents were canvas and kept scrupulously clean. They were highly portable and often moved. The tent served as both Kenojuak's living quarters, where she raised her children, and her studio. The builders salvaged materials from the sea, or from ships that arrived, and installed a wooden door, rather than having to use a less convenient flap.

Kenojuak was very close to all her children, as evidenced by one of her sons, Adamie Ashevak, in the carrier hood of her amautik, and an older son, Arnaqu, in the background. The design of the amautik and the carrier hood fosters a wonderful closeness between parents and children. When growing up, they are constantly in and out of the hoods, being snuggled and always able to feel the warm proximity of their mother. This intimacy from infancy creates a strong sense of self and of being an accepted member of a community.

In the photograph, Kenojuak is wearing a summer-style amautik with bands on the sleeves that are very distinctive of Cape Dorset. Being a coastal settlement, there was a long tradition of trade and barter with whaling ships and also at the local Hudson's Bay Company store. Especially prized were fabric and dressmaking materials that were brought up or mailed by visitors from the South. These could not be found on the shelves of the HBC store. The pattern of the skirt Kenojuak made suggests this is the end result of one of those gifts. Below the skirt are her sealskin boots, which she also made.

"My mother [Alma Houston], when we were in the South, would find some interesting kinds of material and take three or four metres of it, and wrap it up and send it up maybe to Kenojuak or to some other Inuk woman in the community, and they would appreciate that beyond all measure," recalled John. In the photo, Kenojuak has "got a bit of material there that she would have certainly sewn up herself and it's probably a bit of material pattern that's not necessarily duplicated in town."

"There is no word for art [in Inuktitut]," Kenojuak once said. "We say it is to transfer something from the real to the unreal. I am an owl, and I am a happy owl. I like to make people happy and everything happy. I am the light of happiness and I am a dancing owl."[1]

In Eaton's photograph, she is light emerging into the day.

KANANGINAK POOTOOGOOK POSES FOR ROSEMARY EATON in what is likely 1958. His father, Joseph Pootoogook, was a respected man and one of the first in the region to convert to Christianity. Previously, he had held out for quite a long time, telling visiting missionaries, "We have shamans. We're fine." But it is rare to talk to a hunter in the Arctic who has not had a close call. Joseph once fell into the icy ocean on a hunting trip. It's a big test: the ones who have the wits and luck to get themselves out are alive; the rest are gone. Joseph was in dire straits. He was wearing caribou-skin clothing, which soaked up the water and made him heavy as an anchor. He said, "Okay. If you get me out of this one, I'm yours." Whether through luck or divine intervention, he somehow got himself up onto the ice and out of the water. He took off his clothes and wrung them out. It was then vital to get his clothing back on before he perished from the cold and to let his own body's natural heat dry out the caribou skins. Pootoogook eventually walked a great distance to where his people were, and, the story goes, said, "We're gonna build a church, an Anglican church."

In the photograph, Kananginak Pootoogook's parka is perfectly tailored by his mother, Ningeokuluk. She clothed the whole family and was very proud of their place in the community, reflected in their fashion and her work. The colouring and stitch work of the parka are exquisite, as is the fur ruff on the hood. The Pootoogook men, father and son, also broke new ground in taking up printmaking and the arts, a vocation some in Kinngait viewed as a questionable activity for men. Kananginak was to become a mainstay of the print shop, cutting stone blocks for carving and encouraging other men to take up the chisel, pencil or brush and work in the studio.

In the photo, Kananginak is "looking [at Eaton] with a kind of cryptic gaze," observed John Houston. "A kind of expression that shows his self-confidence, a look of amusement and a slightly sly smile, as if his brain is working overtime." Some years later, Kananginak would make the famous print entitled *The First Tourist*, a satiric commentary on tourists from the South. But at this time, Kananginak was just on the verge of becoming a powerhouse in the Kinngait arts co-operative, with his art soon to achieve national and international fame. Perhaps the photo captures a moment of self-realization, his thoughts full of images, ideas and a growing self-assuredness in his artistic skills. A young man discovering a creative path in his life, a new journey.

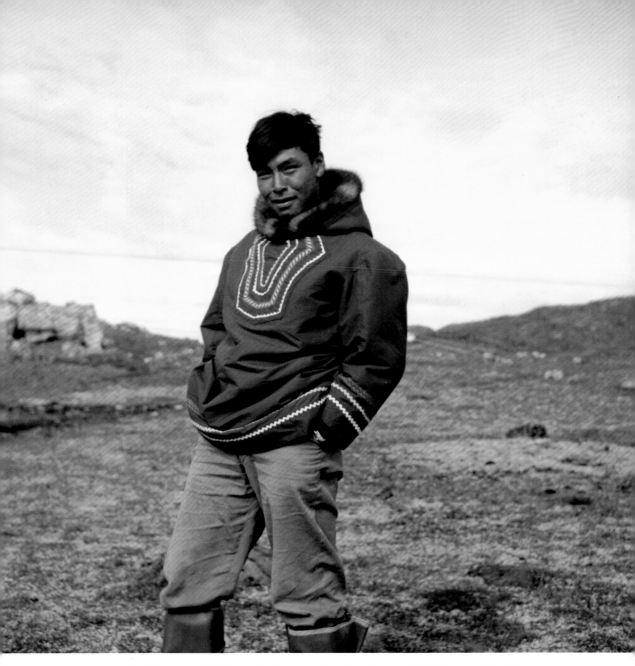

Kananginak Pootoogook (Inuk) poses for Rosemary Eaton, Cape Dorset, c. 1958. (**Rosemary Eaton**)

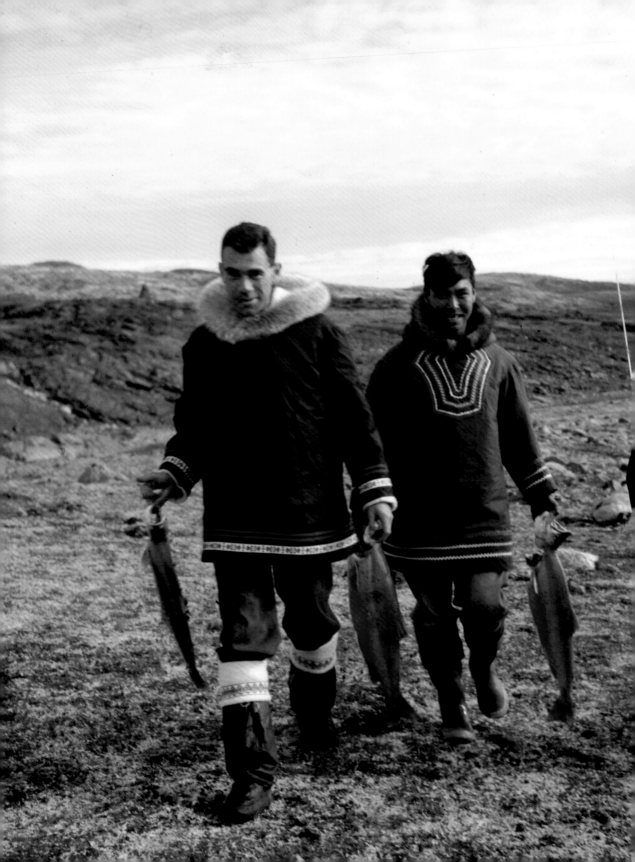

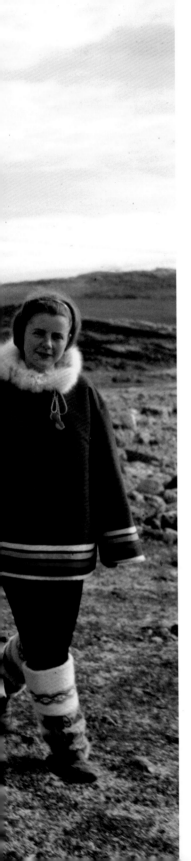

"Back in 1957, I was in Cape Dorset because my father was
ill and as the youngest I had to stay home with my father
who loved me very much. The government asked me to stay
in Cape Dorset with my wife and our little daughter.
At first I wasn't happy, for I wanted to go hunting game when
I could be a man, able to feed my family. By that time there
were nurses, a government and a teacher also in Cape Dorset."
—KANANGINAK POOTOOGOOK

James Houston (left) with Kananginak Pootoogook and an
unknown woman, Cape Dorset, 1958. (**Rosemary Eaton**)

IYOLA KINGWATSIAK, LUKTA QIATSUQ AND EEGYVUDLUK POOTOOGOOK are hard at work in the newly established West Baffin Eskimo Co-operative print studio. The year is likely 1960, and each of these three men will become a well-known artist. They are surrounded by prints reflecting the amazing productivity of these early years. When James Houston returned from a study trip to Japan in 1958, he brought with him the influence of twentieth-century Japanese printmaking, *shin-hanga*, which he had studied under master woodcutter Un'ichi Hiratsuka, and also the concept of working together in making art. Houston, along with Osuitok Ipeelee and Kananginak Pootoogook, developed techniques for paper and textile printing that were similar to stonecutting, carving simple designs into linoleum floor tiles. Some of the art they produced was inspired by the designs on sealskin and caribou-skin clothes and bags traditionally sewn by Inuit women.

From late 1957 until late 1958, using the few materials available, the Inuit artists conducted their experiments with resourcefulness and invention, and created their first uncatalogued, experimental collection. The West Baffin Eskimo Co-operative's first catalogue of forty-one prints was released in Stratford, Ontario, in 1959.

The intensity of this period, in what was then a small studio, is captured in the Eaton photograph as the three men work in the print shop. Many of the prints on display, such as Elleeshushe Parr's *Kayak Hunter*, Kenojuak Ashevak's *Enchanted Owl* and Kananginak Pootoogook's *Untitled (Building an Igloo)*, are now icons of Inuit art and would become central pieces of the first catalogue. In essence this scene is ground zero of the whole conceptualization and realization of the Inuit printmaking process.

In this room, heated by the stove that can be seen in the right of the photo, the three men work with intensity. The studio was a hive of continuous activity, with members of the co-operative coming and going, visitors arriving to view the art, and materials and supplies being brought in. At this time the use of sealskin stencils was already rare, being replaced by more stable working materials such as cardboard and discarded X-ray film, but here Iyola Kingwatsiak is working on what appears to be a sealskin stencil. Using a very sharp knife, he is cutting an image into the skin. He will then lay the cut-out sealskin stencil directly against the print paper, and use a thick stencil brush to tap coloured inks through the openings on the stencil.

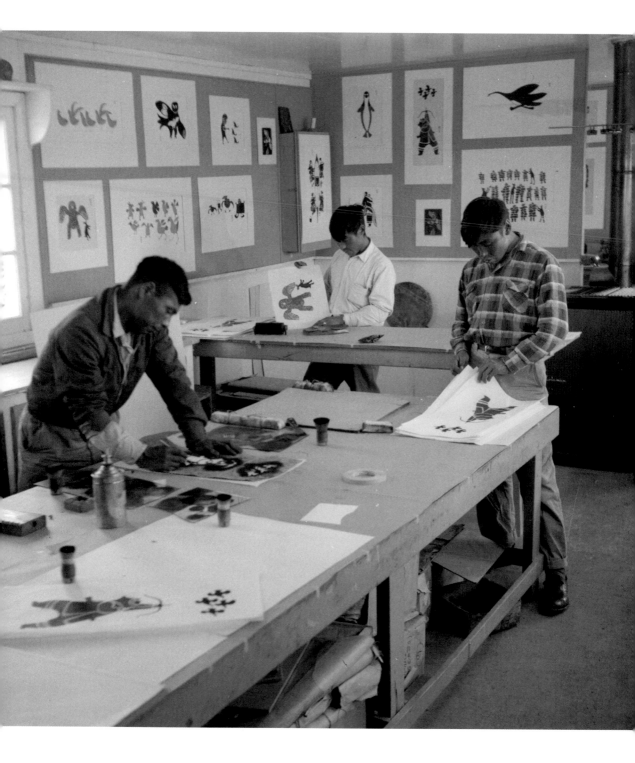

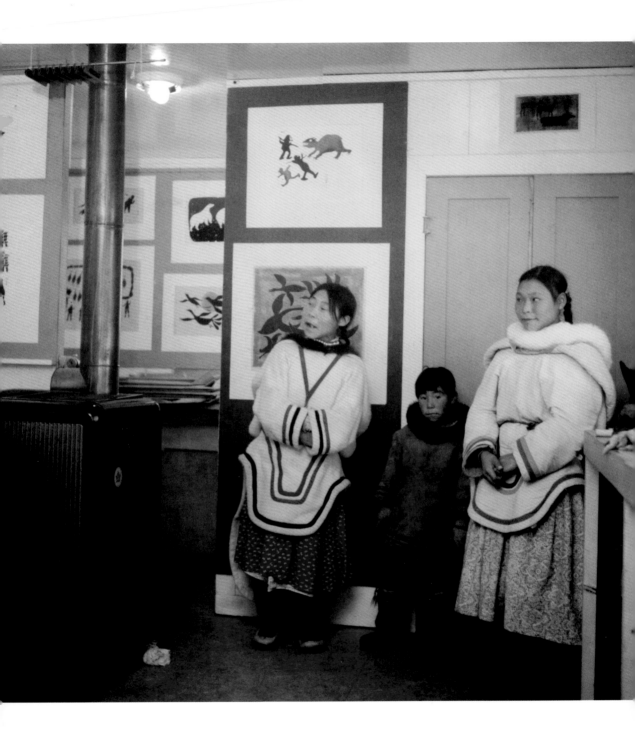

The photo captures a pivotal time in the community and in Inuit art, as this new generation experiments and creates, and gains confidence in the printmaking process. Their prints illustrated scenes from myth, memories of the old ways of living off the land, and contemporary depictions of the varied transformations of daily life in the Arctic and the influence of outsiders.

ROSEMARY GILLIAT'S CAREER BEGAN IN ENGLAND and took her to Sri Lanka and, lastly, to her adopted country of Canada. For over a decade she travelled coast to coast, on assignments, contracts or whatever freelance work she could dig up. In her travels she also displayed an interest, one could say a passion, for Indigenous peoples and communities. She eventually married R. Michael Eaton, and in 1965, for health reasons, settled in Cole Harbour, Nova Scotia, becoming more sedentary, especially as travelling became more difficult for her. Throughout her life she maintained a strong commitment to environmental issues and social justice, but it is her photographs of Inuit that are, perhaps, her most enduring legacy.

Previous page: Artists (left to right) Iyola Kingwatsiak, Lukta Qiatsuq and Eegyvudluk Pootoogook (Inuit) inside the West Baffin Eskimo Co-operative, 1960. (**Rosemary Eaton**)

Left: Sheouak Petaulassie (left), her son and an unknown woman (Inuit), inside the West Baffin Eskimo Co-operative, Cape Dorset, 1960. (**Rosemary Eaton**)

In 1960, Rosemary Eaton and British-born journalist Barbara Hinds discovered they shared an interest in the Arctic, and decided to raise the funds for a trip there. The funding did not come easily, but together they scraped enough together, primarily through the Department of Northern Affairs and what they were able to earn through freelance contracts. Both women were also driven by a desire to see the "exotic" North, and by their shared social consciousness. If they were naive about life in the Arctic, they were also aware that they were outsiders to Inuit culture; they bore an empathy with it and a desire not to be "typical" Southerners. Rosemary remarked on this in her journal:

> *Obviously reporters and journalists have a very bad name here. Some*
> *who come are of course the drinking kind and collect all their material*
> *in the bars, and never move from there. They also complained that too*
> *many people write favourable propaganda-type reports—and others just*
> *write for southern readers the sort of guff on the north that is expected.*
> *I hope that we will not incur their condemnation.[2]*

The two women walked a fine line between selling their texts and photos to Southern readers who exoticized the Arctic and had particular prejudices towards Inuit, and retaining respect for Inuit who were the subjects of their writing and photography. As two women visitor-outsiders, they were also entering an overwhelmingly white male–dominated frontier and were subject to remarks that "women in the North are a nuisance" or that, if they wanted careers, they should be in the typing pool.

John Houston, who was a young child when Eaton visited Kinngait, remembers her with fondness. "She had an empathy for her subjects and a manner that put them at ease. She was willing to go out on the land and she had no airs to her. When you look at her photos, you can see she captures the essence of her subjects."

Kananginak Pootoogook (Inuk) resting,
Cape Dorset, 1960. (**Rosemary Eaton**)

"When I was a boy . . . the only Kadlunaks [white people] in Cape Dorset were the Hudson's Bay Trader, the Roman Catholic Priest, and the people from the Baffin Trading Company. It was like that all of the time I was growing up, but in those days the idea of having to work for our livings never occurred to us. All I thought about was growing up to be a man, having a team of fast dogs, and being able to get all the game I needed. However, I did not travel by dog team for all that many years, for despite what I would have liked to do there were more and more Kadlunaks arriving."

–KANANGINAK POOTOOGOOK[3]

Eaton and Hinds travelled to Iqaluit, Kinngait, and also Kuujjuaq and Kangiqsualujjuaq in Nunavik, among other communities. Eaton considered herself as an impartial documentarian of Inuit life, though this view is now very much out of favour. Photography, especially of a journalistic variety, is recognized as never neutral and involving a series of complex, often unconscious, negotiations and assumptions between the photographer and subject. Still, the Arctic photographs of Rosemary Eaton are a lasting testament to her skills with a lens and her adeptness in capturing this particular, important moment in time, showcasing the land and the people.

IN 1942, WHEN PETER PITSEOLAK (1902–73) got his first camera from a Roman Catholic missionary, he began his journey as the first Inuit photographer. A camp leader and artist, Pitseolak used his self-taught photography skills to document Inuit customs, hunting and camping techniques, and living off the land. He also documented the day-to-day experience of village life in Cape Dorset.

Born in a seasonal hunting camp on Nottingham Island, Pitseolak was ten years old when he met the American photographer and filmmaker Robert Flaherty, who would later produce and direct the famous documentary *Nanook of the North* (1922). Pitseolak credits the encounter with Flaherty for his initial attraction to photography.

Pitseolak had seven children with Annie Pitseolak before her death from tuberculosis in 1939. In 1941, he began a decades-long collaboration with Aggeok, who would become his second wife. With her help, the couple developed their first photographs in a hunting iglu, using a three-battery flashlight covered with red cloth. Pitseolak wrote about, sketched and photographed the Inuit way of life with an intimate perspective. Both his father and grandfather had served as camp leaders, and in 1946 Pitseolak established his own hunting camp at Keatuk on Baffin Island, becoming the leader or "camp boss" of ten families. Over decades he took thousands of photos, of which more than 1,500 negatives survive.

In the 1950s, plagued by tuberculosis, he was forced to adopt a more sedentary lifestyle, living in Cape Dorset, but this did not curtail his journals and visual art, nor his photography. He was present when the West Baffin Eskimo Co-operative began in 1958.

Shortly before his death, Pitseolak recorded, in Inuktitut syllabics, the story of his life and the many changes he had witnessed. *People from Our Side*, a book containing the oral history he had recorded over his lifetime and a selection of his photographs, was published posthumously, in 1975.

Peter Pitseolak (Inuk), Cape Dorset Textile Studio, 1968. (**Charles Gimpel**)

NUNAVIK

For over four millennia, Inuit have lived in what is now the northern Quebec territory of Nunavik. Traditionally nomadic, many adopted a more sedentary existence as recently as the 1950s.

Today, the fifteen villages situated along the coasts of Hudson Bay, Hudson Strait and Ungava Bay—between 1,000 and 1,900 kilometres north of Montreal—are home to more than 10,755 Inuit and 55 First Nations and 50 Metis, with 90 percent of the population being Indigenous. Over 58 percent of the population is under the age of 25. All but the largest four of these villages (Kuujjuaq, Puvirnituq, Salluit and Inukjuak) have populations of fewer than one thousand people. In addition to Inuit, there are around a thousand non-Inuit residents living in Nunavik, according to the last Canadian census information available (2016).

Nunavik's population is young, with more than 60 percent under the age of thirty, twice the demographic percentage of settler Quebec. The natural population growth rate among Inuit is also three to four times higher than the Quebec or national average.

The transition from a traditional lifestyle to a more sedentary one was often turbulent and rife with tragedies, including TB outbreaks, residential schools, and a distant, uncomprehending colonial insensitivity that can be illustrated in the fate of the dogs of Nunavik. Kitty Annanack, the mayor of Kangiqsualujjuaq, told *Nunatsiaq News* in 2011 that she welcomed provincial and regional officials to her community to receive a long-awaited recognition of the dog killings that took place across Nunavik in the 1950s and '60s. In an interview, Annanack recalled how, as a young girl, she watched her father go out hunting on the land with his dogsled team. Other times, her mother would take a few dogs with her to collect wood. "And then we lost our dogs," Annanack said. "We didn't even think of fighting back."[1]

The loss of the dogs was devastating. As a result, many men in the region could no longer hunt, and, as Annanack recounts, many turned to alcohol. A later report by retired Quebec judge Jean-Jacques Croteau found that Quebec provincial police officers killed more than a thousand dogs in what is now Nunavik, without any consideration for the integral role the animals played in the Inuit way of life. In 2011, then Quebec premier Jean Charest and his Native Affairs minister, Geoff Kelley, arrived in Kangiqsualujjuaq to acknowledge the suffering the killings had created for Inuit families. Annanack called it an overdue "relief."

"It was emotional for me because I witnessed this happen, and now my parents have passed," she said. "I was trying to be strong. We cannot go back."

Minister Kelley said Makivik Corporation[2] and the Kativik regional government raised the dog slaughter issue during the first discussions with Quebec on Plan Nord (the provincial government's plan for the economic development of the North). "It seems like such a long time ago, but the memories are still there," he said. "There was a high level of misunderstanding and miscommunication, and not much respect for the Inuit culture." The recognition of the injustice of the dog killings also came with $3 million in compensation, provided to Makivik Corporation, as well as commemorative plaques for each of the Nunavik communities. The trilingual plaque, titled "The Nunavik Qimmiit," reads:

> *The Government of Québec acknowledges that the Nunavik Inuit community suffered from the impact of the slaughter of sled dogs during the 1950s and 1960s and that many people were affected. Since that time, our relations have improved such that a similar situation could not take place today. Consequently, Québec recognizes the Inuit people and their modern vision of the role of the Qimmiit [sled dogs].*

Harry Okpik's story[3] is emblematic of the huge personal and societal changes that shook Nunavik in the past half century. As captured in the documentary *Okpik's Dream*, written and directed by Laura Rietveld, his childhood was centred around his father's dogs. Harry Okpik grew up in the late 1950s and early '60s. There were no recreation centres when he was growing up, so running the dogs and training the young puppies with harnesses was more a source of entertainment than a chore. The dog teams were also a vital mode of transportation. Okpik rode on his father's dogsled on hunting expeditions and dreamed of having his own team, like his father. Then came the government-led dog slaughters. It is estimated that twenty thousand sled dogs were killed over the course of two decades.

Men who had relied on the dog teams to feed their families suddenly had none. Snowmobiles were eventually introduced to replace the dogs, but they lacked the animals' innate sense of direction and safety, Okpik later observed, required technical maintenance and would often break down, occasionally stranding their owner, with sometimes fatal consequences.

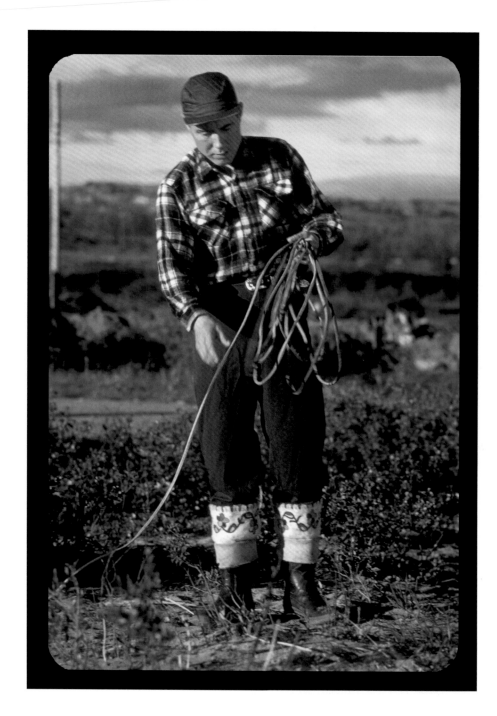

"I don't remember ever, even up to now, [hearing of] an Inuk dying hunting by dogsledding," Okpik said.

When he was seventeen, Okpik left Quaqtaq for the first time. He was sent west, across Hudson Bay, to the Indian Residential School in Churchill, Manitoba, for two years. He was grateful to learn English, but there was not much else good to recount.

A few years after Okpik's return from the Churchill school, he had an accident. He was twenty-two, hunting with friends. While loading his gear and seal meat on his snowmobile, he accidentally shot himself with his own rifle. The bullet shattered his femur and he was fortunate to survive, but it was at the cost of his leg. Okpik was hospitalized and distanced from his community, trapped in an alien world where no one spoke his language. He began drinking and became an alcoholic. It was only when he came home that he was able to sober up.

Harry Okpik credits his recovery to the gradual return of the sled dogs, after the government stopped culling them. Today, he says, "my most relaxed moment is when I'm with my dogs and I'm in another world, in my own world and I'm getting strong. I wanted a very clear picture of the impact that the residential school [system] and the dog slaughter had on my age group. I had to re-educate my mind. My body. The way I move. The way I think. I'm sixty-one now but I only feel twenty-four."[8]

GEORGE AQIGGIQ KONEAK IS GATHERING ROPE. It is summer 1960 in Kuujjuaq, Quebec, formerly known as Old Fort Chimo (a lot of the name changes started to happen in the 1950s). George Koneak was born on January 3, 1931, in a snow house.[5] He recalled that his parents were travelling back to their inland camp by dog team, after holiday celebrations at the Hudson's Bay Company's post in Quaqtaq, when his mother suddenly felt the onset of contractions. His parents stopped and hurriedly put up a snow house.

George Aqiggiq Koneak (Inuk) with rope,
Kuujjuaq, Quebec, 1960. (**Rosemary Eaton**)

"I was born maybe a half-hour after the snow house was built," Koneak said. When he was a child, his family always travelled at Christmas time back to the post from their camp near Diana Bay (now Tuvaaluk), Quebec. More than two hundred Inuit from nearby camps would gather there, building temporary snow houses for their holiday celebrations. These festivities began in earnest on Christmas Eve, when the Hudson's Bay factors (chief traders) treated everyone to a feast. Then there was dancing to accordion music.

"The feast, it was pork and beans," Koneak recalled with a laugh. "They would make a big batch of pork and beans, lots of bannock, with lots of raisins in the bannock. When the dance would come around in the evening, everyone would fart!"

At midnight, the festivities paused for a church service. There was a church in Old Fort Chimo where religious services were held on Christmas Eve and Christmas Day. This church was later moved to Kuujjuaq, where it is still standing.

Present-giving, remembered Koneak, was also part of the holiday then, but not as formal as today. "People were giving something, but nothing new or bought," he said. "Older people would make sealskin lines [for use in dog teams] and packs. Some people would trade jackets and parkas."

Koneak moved with his family to Old Fort Chimo in 1958, and the community would soon relocate closer to the US Air Force base, a NORAD location during the Cold War. There, he was introduced to another way of celebrating the Christmas holiday, with lights, decorations, trees and wrapped gifts. Games were also an integral aspect of Christmas, with indoor and outdoor games as well as dog team races.

"George Koneak was my father's first cousin," said Taqralik Partridge. "He was a very well-respected man. He looked quite white, but he was Inuk, Inuk, Inuk."

In a 2005 interview with Isuma TV, Koneak, through an English-language interpreter, spoke at length about the effects of climate change, the changes to the land and seasons, and what he had noticed in his own lifetime.

"What I've noticed over the past years is the heat of the sun is a lot stronger now," Koneak said. "Now we have to use sunscreen lotion to keep from getting burned. In the past we never had to do that. As well, we see animals that never used to come around here. Polar bears and walruses that are getting closer to the forested areas.

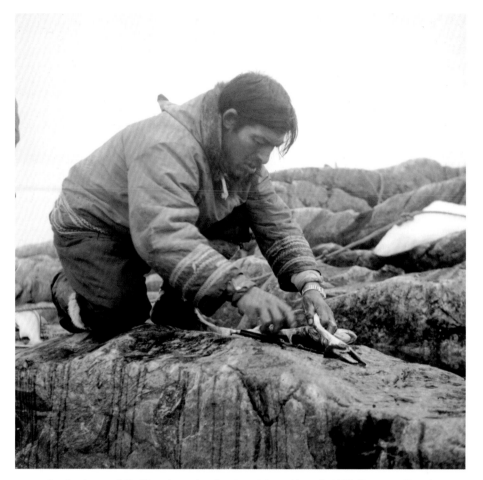

Stanley Annanack (Inuk) gutting a char, Kangiqsualujjuaq, Nunavik, 1960. (**Rosemary Eaton**)

"[When hunting] we can't use our old paths anymore. We used to go on the land, but we can't use those trails anymore. We can't go overland, we have to wait for the ice breakup to go to the areas we used to go to hunt. There's a lot of differences. I've touched the beginning, how it was, and [how it is] right now. I've felt the difference between those sealskin lines [for dog teams] and now a Ski-Doo at Christmas."

THE ANNANACK FAMILY WERE RESPECTED IN THE REGION, though they had lived through hard times. In 1960, George Annanack recounted a story to Inuktitut translator George Koneak about his great-grandfather, a tale of starvation and self-sacrifice. On a trip back to Ungava Bay from the Labrador coast, his great-grandfather was unable to walk anymore as he was too weak, and there was absolutely nothing to eat. They knew they wouldn't make it back. His grandmother told him, "You must eat me as you're not going to make it."

His great-grandfather told her he couldn't do that. "I can't kill you. I will die with you."

His grandmother replied, "You cannot do that. If you don't eat me and die with me, there will be no more family left alive. If you eat me, you may make the trip back to Ungava Bay and you will keep the family alive."

She argued hard for him to kill her. "Take this rope and put it around my neck. Then go outside the snow house and pull on it. That way you won't see me suffer. You can stand outdoors and please do this. Hang me inside the snow house." Reluctantly, Annanack's great-grandfather finally agreed, and afterwards he had the strength to keep walking towards Ungava Bay. He was the only one left. And he made it.

"It's a very sad story, even now," Annanack explained to Koneak. "However, that man survived. He got married and had children and that's how the Annanack family started to grow again and why there's Annanack children today at George River." The family later moved to Kangiqsualujjuaq, Nunavik.

Annie Johannesee with Johnny (Inuit),
Kuujjuaq, Nunavik, 1960. (**Rosemary Eaton**)

Imaapik Jacob Partridge (Inuk), Kuujjuaq, Nunavik, 1955. (**Rosemary Eaton**)

"I was sixteen. Think I was showing off [to her] a bit."

—JACOB PARTRIDGE, recalling the day when Rosemary Eaton took his photograph.

IN A 1999 INTERVIEW IN *Northerners: Above and Beyond,* Jacob Partridge, Taqralik's first cousin, spoke of the fiftieth anniversary of his homecoming to Kuujjuaq. In 1949, he returned from his hospital internment in the South for tuberculosis.

The youngest of eight children, Jacob was named Imaapik at birth. His family lived out on the land near Quaqtaq, Nunavik, and came into the settlement of Kuujjuaq (Old Fort Chimo) to trade for goods. However, when Imaapik was two years old, he could no longer walk and began to experience pain in his hip. His parents decided to take him to Kuujjuaq for medical treatment.

His mother, Siasi, was the keeper of the family's discs—a numerical identification the colonial authorities gave out to Inuit to identify them, as they found the names difficult to pronounce. Each disc's number identified a person. When the family were getting ready to take Imaapik to the nursing station, his mother looked frantically through the collection of discs, afraid her baby would be denied treatment without it, but couldn't find the one belonging to him. Imaapik had been using a disc for a soother and, assuming it was his, his mother brought it with them. However, it turned out to belong to her grandson, Jacob Kudluk.

The nurse couldn't identify Imaapik's ailment but knew he needed to be sent south for treatment. The nurse convinced his parents to send him south and wrote his name down as Jacob. His mother argued through an interpreter that that was not his name. But the nurse didn't listen to her about the mistaken disc number. Finally, his mother burst out in Inuktitut, "Okay, then! Call him Jacob so he can be sent out to be cured!"

Jacob vividly remembers how sick he was when he first arrived at the hospital in the South. He developed terrible diarrhea from the strange foods he was forced to consume. He had been raised on a traditional diet of mother's milk, fish, seal and caribou meat. The cow's milk and cooked vegetables he was now fed were next to impossible for him to digest. Imaapik's story was sadly familiar to a lot of Inuit children sent south for TB treatment at the time.

Jacob was sent to Halifax for treatment to his left hip bone, then transferred to Toronto. He was in the hospital for nearly seven years, endured several operations, and spent five years in a body and leg cast. Though Jacob eventually recovered, one leg would always be shorter than the other and he ended up walking with a limp.

When he was eight, the doctors pronounced him cured and said he could return home. But Jacob no longer knew where "home" was, having been a small child when he'd arrived in the South. The nurses brought him a map of Canada and asked him to point to where he came from. He had no idea. It was the first time the eight-year-old had seen a map. Finally, sobbing, he pointed to his favourite colour on the map: blue. By chance, his finger had touched on Ungava Bay.

The Partridges didn't know what had happened to their son. They sent a letter south, in an effort to learn his whereabouts, and five years later that letter finally found its way to the hospital in Toronto. It was written in syllabics and a Cree patient was the only one who could read it. She was brought to Jacob and asked him questions that later helped to discover the location of his home.

Around the same time, a nurse who had worked in the Toronto hospital where Jacob was treated was stationed in Kuujjuaq. While she was there, she heard about a family named Partridge that lived out on the land. The name wasn't common and she wondered if they might be related to the little Inuit boy she'd met in the hospital.

One day when the Partridges were in town for supplies, the nurse sought them out to ask if they had a little boy named Jacob who had been taken south at a young age to be hospitalized. The answer was no. But then Siasi Partridge re-membered the argument she'd had, years ago, with another nurse, who had changed Imaapik's name to Jacob, based on the wrong ID disc. She realized this Jacob was indeed her little boy.

"Yes," she told the nurse. "He is my son."

In the summer of 1949, seven years after he had been taken south, a plane brought Imaapik north to Kuujjuaq. At last, Imaapik Partridge was home.

Now in his seventies, Imaapik remembers that day vividly. When the people of Kuujjuaq heard that Imaapik Partridge was coming home, the women lined up along the shoreline, a sea of red plaid, to welcome him. He came ashore, shaking every single person's hand, babies included.

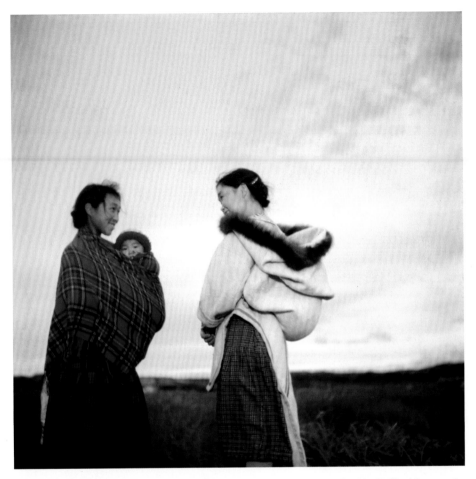

Elisapee Partridge (left) and Lizzie Gordon Saunders (Inuit), Kuujjuaq, Nunavik, 1951. (**Wilfred Doucette**)

The red plaid fabrics were distinctive of Nunavik and the fabric
carried by the Hudson's Bay Company store. An ulipakak is a plaid
shawl used to carry a baby. "Red plaid was the traditional garb for
women then," explains Taqralik Partridge. "Though nowadays
you see a lot of Gordon tartan, which is navy."

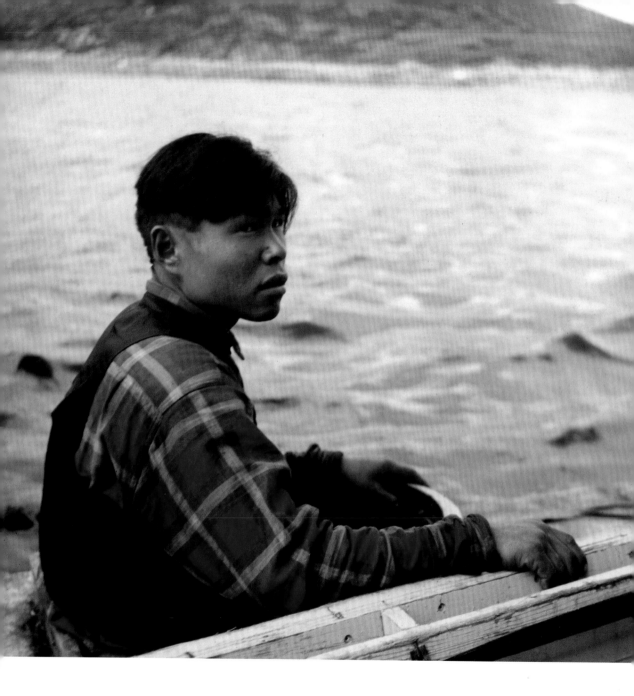

Johnny Morgan (Inuk) in a qajaq,
Kangiqsualujjuaq, Nunavik, 1960. (**Rosemary Eaton**)

THE PHOTOGRAPH OPPOSITE, TAKEN IN KANGIQSUALUJJUAQ, is of Johnny Morgan in a qajaq (kayak) he built in 1960. Johnny Morgan also worked at the newly opened char cannery, as evidenced by other photos Rosemary Eaton took during her visit there. But it is the photographs of Morgan in his qajaq, dockside, and one of him at sea, that stand out.

Many of the materials required for assembling the qajaq, including sealskin, wood and branches, were harvested directly from the area. He built the qajaq with traditional tools and techniques. He cut flat boards to appropriate sizes with handsaws and further shaped them with hand planers and whittling knives. He made holes in the wood with a bow drill wherever pieces of the qajaq were to be joined, allowing them to be firmly tied together with sinews. When the top of the qajaq frame was completed, tree branches were steamed over boiling water and bent in half to form the boat's ribs. A wide, flat piece of wood was boiled and shaped into a circular form to serve as the cockpit in which the paddler would sit.

The skin covering was one of the most important parts of the qajaq. As it is completely waterproof, sealskin keeps the boat buoyant and also ensures that its user stays dry. While qajaq hunting was typically considered to be a man's skill, women were traditionally responsible for sewing the qajaq sealskins. The name of whoever assisted Johnny Morgan in the building of his qajaq is lost to history. While both seal and caribou hides were used for qajaqs, it is most likely that Morgan's was covered with sealskin, as that was much more available, on a consistent basis, in the region. The seal meat was eaten, and then traditionally the skins were given to women to be carefully stripped of fat and hair with ulu knives. The clean sealskins were next soaked in salt water, and the holes from the removed front flippers were patched. Then, relying on string measurements from the wooden qajaq frame, the sealskins were connected end to end, and sewn together with sinew using an intricate stitch also typically employed in making waterproof kamiik boots. In old times, seal oil would be used to soak the sinew thread and the sewn edges of the sealskin, but at the time of Morgan's qajaq more modern oils and materials may have been used. While still wet, the sealskins were stretched over the upside-down qajaq frame and sewn tightly into place.

The one-person boats were usually just that—"made to measure" for one particular person, fit for his size and weight. No doubt Johnny Morgan's qajaq was carefully constructed and sewn just for him. There is no doubt either that Johnny would have practised near shore at first. Should a person fall into the water or drown when qajaq hunting, it was often said that he must have borrowed someone else's qajaq, and didn't have the same sense of balance. Being able to right oneself if tipped by a wave was an obvious early lesson.

Boy wearing cap (Inuk),
location and name unkown,
c. 1960. (**Rosemary Eaton**)

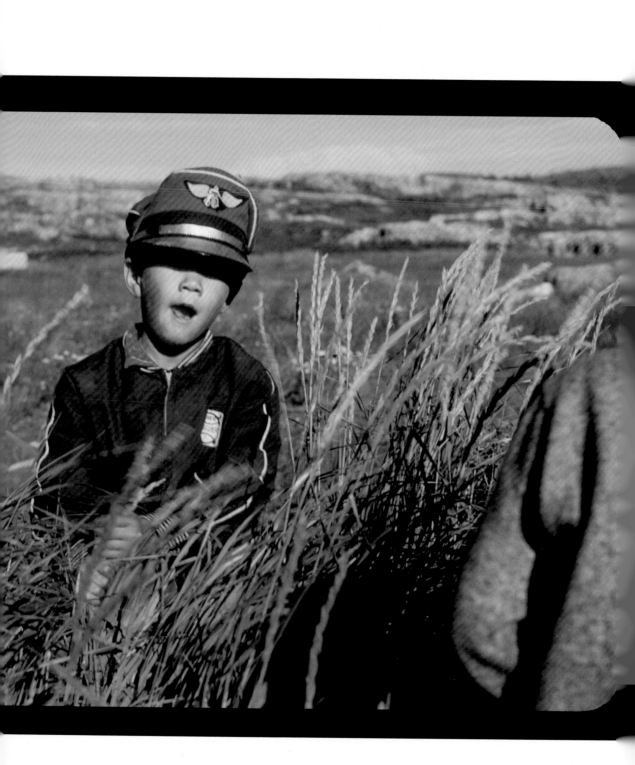

LAND OF THE PEOPLE

JAMES BAY AND HUDSON BAY WATERSHED

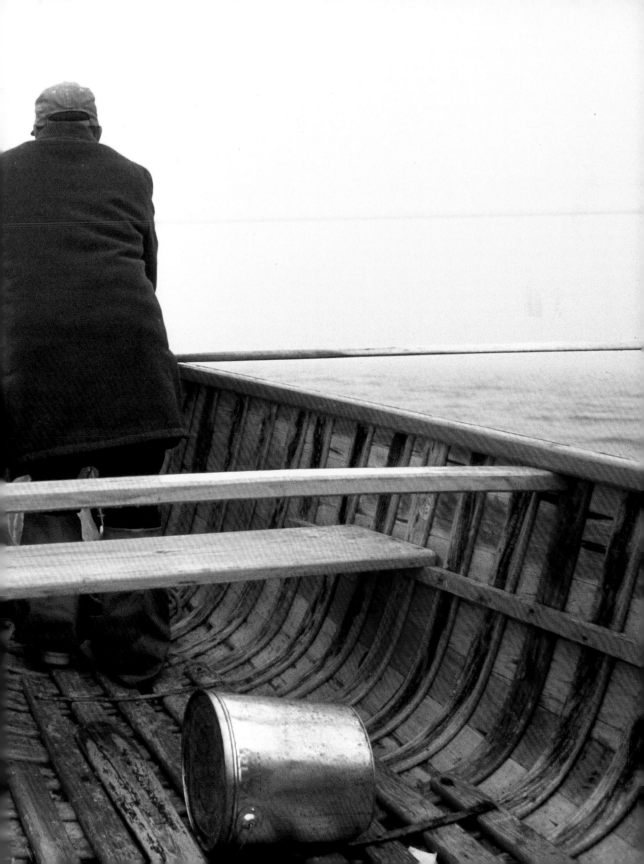

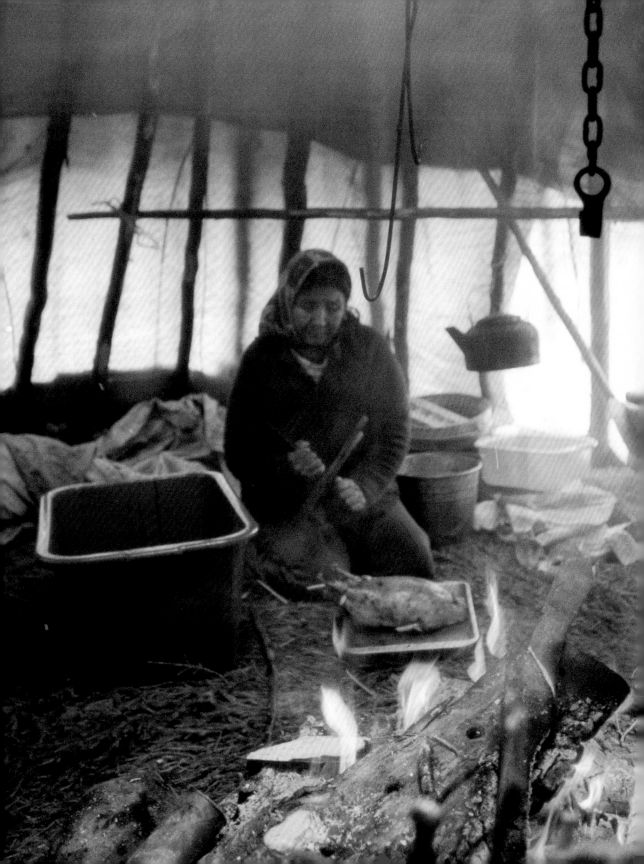

JAMES BAY

The "Land of the People" in Cree, Eeyou Istchee (or Iiyiyuuschii), is a vast territory in modern-day Quebec with many lakes and rivers that drain into eastern James Bay and southeastern Hudson Bay.

Today, the communities of the Eeyou Istchee occupy 5,586 square kilometres. But Iiyiyuuschii was traditionally a much larger territory, comprising about 450,000 square kilometres—roughly two-thirds the size of the province of Alberta. The land itself ranges from dense forests in the south to salt marshes and islands along the coast to tundra in the north. For thousands of years the Cree have lived off the abundance of this land through hunting, fishing and trapping. The land also provided shelter, material for transportation and medicines for healing. The caribou are no longer around, but other traditions endure, such as the annual spring goose hunt. For this hunt the whole community essentially shuts down, as students take breaks from school to return to their homes, and families participate together.

Today, the sixteen thousand Cree of Iiyiyuuschii live in nine communities: along the coast are Waskaganish, Eastmain, Wemindji, Chisasibi and Whapma-goostui; further inland are Waswanipi, Nemaska, Oujé-Bougoumou and Mistis-sini. Adaptation and resourcefulness are hallmarks of survival on this land, and with modern technologies widely available, all-terrain vehicles, snowmobiles and powerboats are now more common than traditional snowshoes, canoes, sleds and dog teams. Still, going "back to the land" is more than a cliché, it is a reality: camping, hunting and fishing remain essential parts of the Cree way of life, and a connecting thread between generations that maintains both the Cree language and the Cree way of being.

In 1974, the Grand Council of the Crees formed as a political entity in response to the "project of the century," a mega-dam to harness the rivers in James Bay, announced by the Robert Bourassa government of Quebec in 1971. As will be outlined later in this chapter, this project was an awakening, not only for the Cree of Eeyou Istchee that their land and way of life were under threat, but also for the politicians and people of the South, who for so long had assumed the North was simply a wilderness to be used, regardless of the original inhabitants who lived there.

Sovereignty and self-determination are not simply concepts for lawyers and politicians, nor are they overruled by projects for resource extraction or by funding agreements; they are issues that directly impact the lives of every person in the region, from birth to death. Today in Eeyou Istchee, Cree women are sent to

Val-d'Or, Chibougamau or Montreal to give birth, meaning they are separated from the support of family and friends as they give birth in a foreign environment. A recent initiative of the Cree Board of Health and Social Services aims to team up modern midwives with women elders to reintroduce Indigenous midwifery into the communities and enable birth to happen once again at home,[1] as it has for thousands of years.

"I was born on the shores of Rupert River about four miles west of the Cree Village of Waskaganish," Chief Billy Diamond (1949–2010) wrote, recounting his childhood.

It was called Rupert House back in 1949. There was no doctor or nurse at my birth so my dad had to do the delivery. My foundation years included the times of going up the Nottaway River to get to our family hunting and trapping grounds. Our mother carried us on her back through the long portages. Sometimes, I helped pull a rope to assist in getting the loaded canoe up the swift, fast currents of the rivers. I remember dad and the other men would leave at first light with a load of supplies and equipment in a canoe and then they would return to get the women and children. You were instructed to paddle and work with the grown-ups, but sometimes laziness got the best of you [and] I took it easy at the bottom of the canoe. I felt the sense of safety and security with my dad at the stern of the canoe and my mother at the bow of the canoe as we kids played and laughed—or sometimes a fight would break out—at the bottom of the canoe. A stern warning was barked out by dad and that is all it took to keep us in place.[2]

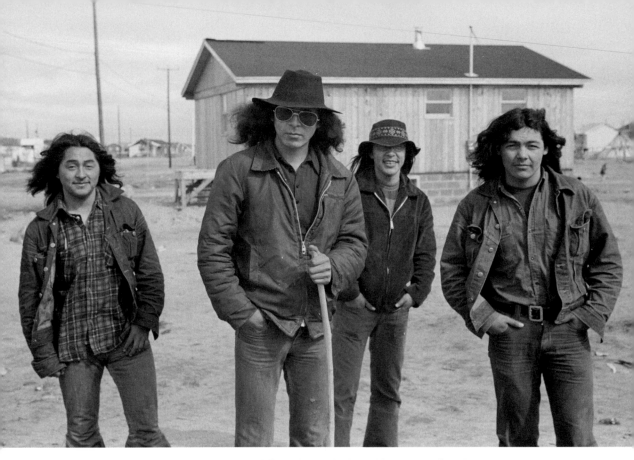

Fort George Rockers (left to right): Michael Sam, Oliver Rupert, Elmer Sam, and Samuel Horse (Cree), Fort George, 1973. (**George Legrady**)

OLIVER RUPERT, HOLDING A STICK, is the founder and lead guitarist of the Fort George Rockers, a rock band formed in 1972 and still playing in 2017. Rupert remembers photographer George Legrady "hanging around," but the band didn't pose for this photo. In 1974, roughly a year after the photo was taken, Rupert and his band embarked on what was probably the first-ever rock tour by canoe, visiting three James Bay communities.

Rupert recalled, "It was the summer of '74. The month of August. We had planned that summer to go on a tour with canoes, freight canoes. Twenty-four-footers. At that time there was only twenty-horsepower outboard motors available.

We left Fort George early in the morning. Usually in August it gets windy before the fall, so we left Fort George early morning to go to the next community, Wemindji [at that time called Old Factory]. That took us all day to get there.

"We had three canoes and we hired about twelve people to work with us. At that time we didn't have that much equipment. It was just mostly amplifiers, guitars, drums. We made it to Wemindji that first day, in the evening. As we were supposed to play that evening, [one of the] guys had to clean his guitar because it got wet [on the journey]. We set up our amplifiers while he cleaned his guitar and by the time we finished setting up, it was getting close to showtime. He came with his guitar, was going to try it, and he still had his hip waders on. He plugged in his guitar and luckily it worked and he started playing. I think he was the only guy [in rock history] who ever played with hip waders onstage."

As they left the next morning, the winds picked up and the water became too choppy for the three canoes. "We couldn't make it any further, so we had to sleep halfway to the next community, so we slept out in the bush. Put up a temporary little tipi. Some of us got some sleep, some didn't. We were sitting [on the shoreline] of the little bay when we saw a beluga whale swimming by. One of the guys wanted to shoot it, but we said not to shoot it. We had one woman who came with her boyfriend, she was pregnant, so we told him not to shoot the whale because it might wake and scare her."

That morning the winds calmed and they were able to travel to the next community, which was Eastmain, Quebec, where there was a wedding that evening and one of the band members was the best man. After the wedding, they played to an appreciative crowd. "We left that morning, but before we got to the bay, one of our motors broke down, a 20-h.p. So one canoe was left in the community to see if we could borrow another motor. After two hours, they came back with a motor, which was 25-h.p. and faster than the other ones we had."

But once again the wind and waves picked up, forcing the three canoes to again make for shore and safety. That night the band and entourage camped out in the bush, but this time they were plagued by hundreds of mice, which they had to chase away. The next morning the bay was calmer and the tour resumed in time for the Fort George Rockers to play their last gig in Waskaganish.

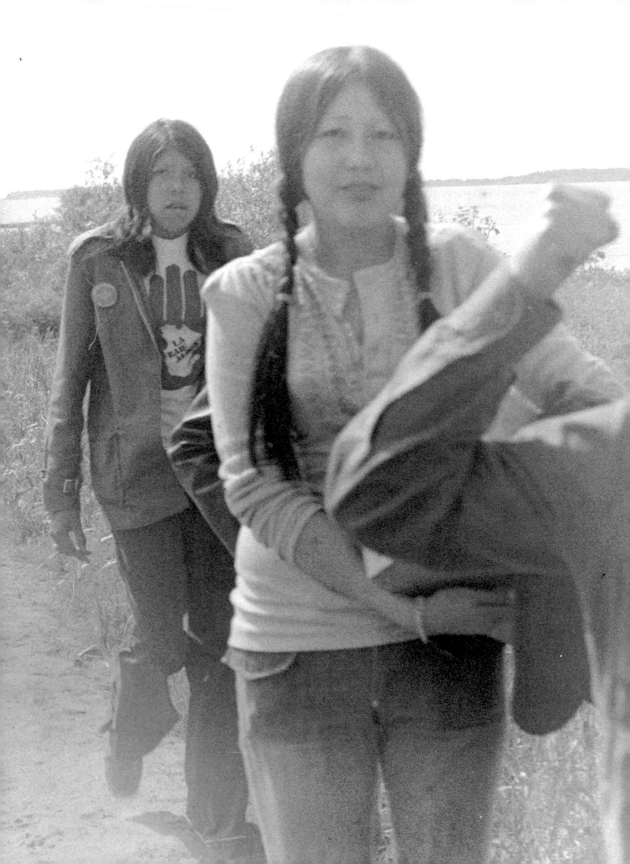

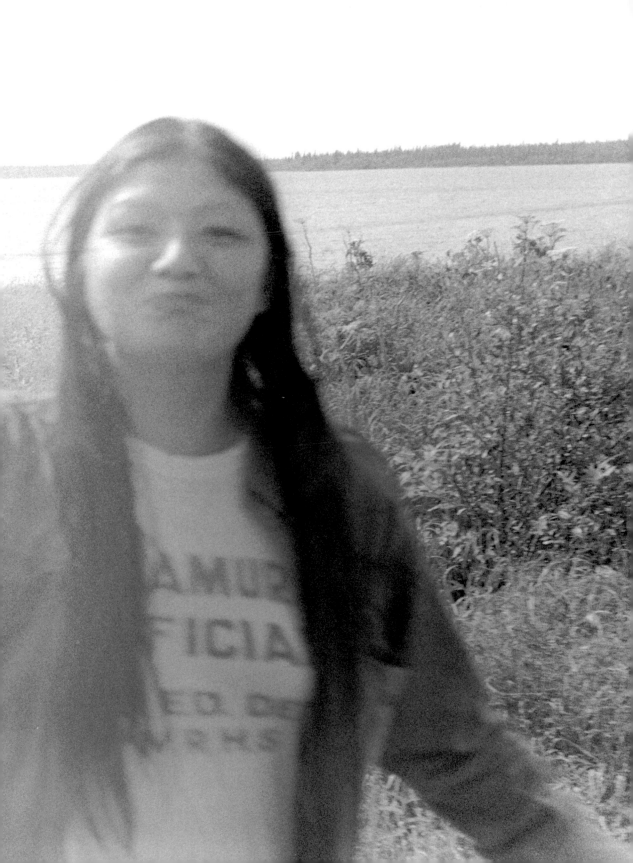

On April 28, 1971, Quebec premier Robert Bourassa announced the "project of the century": the James Bay hydroelectric dam, which would harness the power of eleven major rivers flowing into James Bay and Hudson Bay.

These eleven rivers, and the land around them, more than anything else, defined the Cree way of life: the hunting and fishing, the camping and gatherings, and the traditional values that were passed down through many generations. As Billy Diamond, who would become the first Grand Chief of the Grand Council of the Crees, later recounted, "There was no visit from anyone to the Cree communities to explain the proposed hydro project, and there was no material available and there was no consultation."

The "Project of the Century" galvanized the Cree leadership in the James Bay communities, bringing them together to defend their rights and, importantly, the land. "We were young and just beginning to hear about the project and what it would mean," Gordon Neacappo remembered. "It brought people together."

George Legrady spent three months[3] in the communities of Fort George (Chisasibi), Wemindji, Eastmain and Rupert's House, at a time when legal hearings with the Quebec government had been going on for two years, with no resolution, and the official formation of the Grand Council of the Crees, a political entity representing the James Bay communities, was still a year away but very much in the making.

"One of the most painful things was the kids being sent south to school," Legrady explained. "But one of the things it did do was give a young generation of the Cree a sense of the white man's system and how they did things. Out of that, Billy Diamond eventually got the federal government to take the Quebec government to court over the James Bay [hydroelectric] development."

Diamond said, "The Cree Elders taught me to seize the opportunity and to make it a Cree issue." He recalled the elders saying, "It is not about you, but about the Cree people. To build an opposition you need some people who will believe in your idea that we Cree have rights."

A meeting was held with Robert Bourassa in the third week of October 1972. As was Cree protocol, the elders spoke first after the initial introductions. Malcolm Diamond, Billy's father, explained in Cree what the rivers and the land meant for

the people, but before Malcolm could finish, even before the translation was given, the premier packed up his papers, told the Cree delegates he had no time for this and walked out of the meeting.

"We were stunned and shocked at what had happened," Billy Diamond said.

And I dared not look at my dad for I felt the shock and humiliation that the premier would act in this way. I stared straight ahead and could not believe in the turn of events. My dad slowly walked toward me and in a quiet voice said to me, "We have raised you up for this purpose. I sent you to school and the people chose you to lead. So lead and use the white man's law to stop this hydro project and get our rights recognized. It is up to you young people now. We will be there to advise you and help you."

Previous spread: "Stop James Bay" (left to right):
Laura Moses, Josephine Mayappo and Beatrice Gilpin (Cree),
Eastmain, Quebec, 1973. (**George Legrady**)

"GOOSE BREAK" IS A TRADITION that goes back thousands of years for the Cree of Eeyou Istchee. Goose Break hunting begins at the end of April and continues for a week or two. It involves families throughout the James Bay region of northern Quebec, who leave the towns and return to the land as the flocks of Canadian and snow geese return from their fall migration south. The centrality of the hunt to lived culture, and the community feasts that follow when the hunters return to the towns, is as important today as it was long ago. There is a continuity to the goose hunt that has remained unaltered, regardless of any "modern" changes to the traditional way of life, such as motor vehicles, electricity, television or the Internet. There is a nomadic spirit inherent to the hunt, of getting back on the land and camping, of killing your first geese.

Rusty Cheezo and Kenneth Gilpin (Cree), heading off to a hunt, Fort George, Quebec, 1973. (George Legrady)

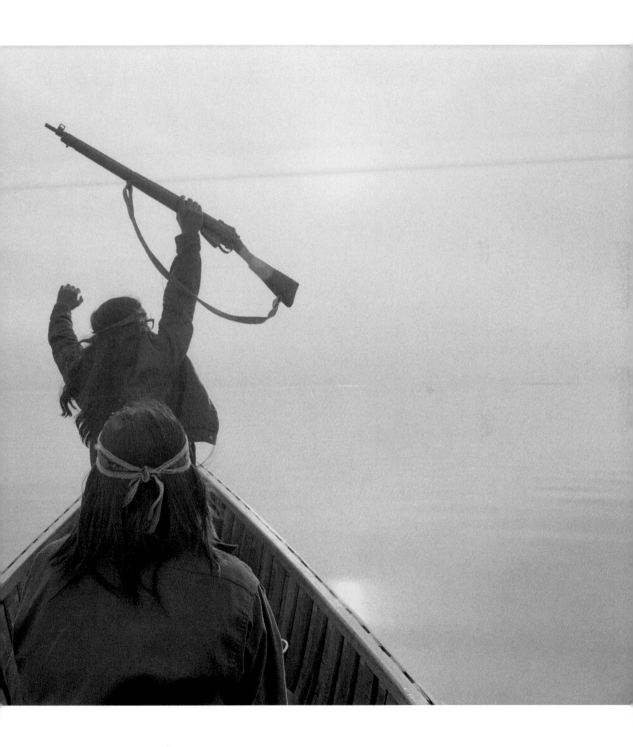

"The best Cree hunters were not always the fastest. They were not always the strongest. They were not always the smartest. But the best hunters were always the most humble and the most generous," Bradley Georgekish of Chisasibi explained. "They were always putting the well-being of their camp ahead of their own. Always sharing their harvest and the tools it provided. Always sharing their skill and knowledge to strengthen the camp. Always respecting their elders. Never being boastful or expecting anything in return."

Beyond the shared experience of the hunt itself, there is also a rekindling of the necessity and strength of working together, of sharing knowledge, and of knowing how to be out on the land—values that were vital for survival in the old times. And often still today, when a boy kills his first goose, the head of the bird is cleaned, stuffed, sewn and decorated with beadwork. The memento is kept in honour of his first hunt. With more girls going out on the hunt, chances are this honouring could be for a girl as well.

"Some of the students are lucky that their classes and exams are over in the South so they can come home for the goose hunt," said George Neacappo of Chisasibi. For those students, the goose hunt supplements a southern education as they become the recipients of land-based learning from Cree elders—skills such as hunting safely, making a goose call, practising patience while spending time in a goose blind, and cleaning their own kills.

Once the hunt is over, and the hunters have returned to the towns, the sharing of Cree culture and tradition continues with the cooking of the geese in a large tipi, by an open firepit, with plates catching the grease from the basting geese. The Cree word *sigabon* refers to the method the James Bay Cree use to cook Canada geese by suspending them with string from a rack in a mitchuap (large tipi) and spinning them around at the edge of the open fire. Often, a special wood is used for the firepits, from burnt forest that was harvested two or three years earlier. The wood imparts a special flavour to the geese—delicious.

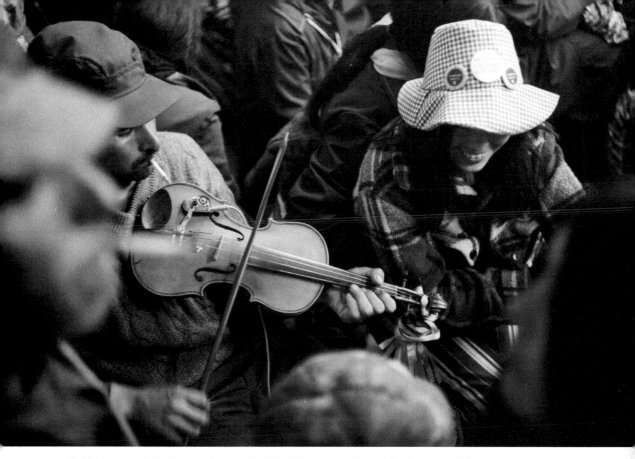

Bobby Georgekish, fiddling, and Evadney Hughboy Kakabat (Cree), Wemindji, Quebec, 1973. (**George Legrady**)

BOBBY GEORGEKISH WAS ONE OF SEVERAL LOCAL FIDDLERS in the James Bay area. In this George Legrady photograph, he is playing at a community wedding. The music and the dancing would carry on till early morning. As Legrady recalled, he was from the city, where country music "simply wasn't cool," and "suddenly I'm hearing this two-hundred-year-old Scottish bluegrass."

In November 2011, music scholar Frances Wilkins interviewed Georgekish, with the assistance of Cree interpreter Dorothy Stewart.[3] They talked about how Georgekish first picked up the fiddle and how fiddle music arrived and took root in the region.

Georgekish told Stewart he was about fifteen years old when he would watch people play the fiddle. Listening to and watching the fiddlers was the way he learned. Like most other Cree fiddlers, Georgekish never had any formal instruction, learning to play on his own and by jamming with others. Georgekish related how, whenever he heard a tune he liked, he was determined to play it, and that's how he improved his fiddle playing. "I would gradually get better at playing them," he recalled. Through constant practice, he got the music to sound the way he liked.

Georgekish told Wilkins and Stewart about the origins of fiddle music in the James Bay region as he understood it. He spoke about how, at Old Factory (now Wemindji), big ships used to come into port, and there were people who played tunes on their fiddles. He guessed Cree people gradually heard those tunes all the time, and that's how they acquired the fiddles and the music. He was also aware of the late Ray Spencer from the community, who had ancestors and relatives in Scotland, and that provided another connection.

Georgekish told Wilkins and Stewart that many times, when people wanted to have a dance, they would simply walk around Wemindji. At the time, many in the community didn't have houses—some lived in tipis—and people would be yelling, "There's going to be a dance," waking others up so they would come. He remembered playing at many of these events.

Georgekish also composed his own song, the "Wemindji Bridge Reel." He explained how, when you're coming into town, you're sort of going downhill, and you're applying your brakes, and the movement of the vehicle inspired the sound of the reel. "The first half of the tune is quite smooth-sounding," Wilkins said, "signifying the drive down to the bridge as you're putting the brakes on in the car, and the second half sounds very bumpy, which appears to emulate the feeling in the car when you are going across the bridge."

GEORGE LEGRADY IS AN ARTIST WORKING IN PHOTOGRAPHY, digital media interactive installations and data visualization. Born in 1950 in Budapest, Hungary, Legrady immigrated with his family to Canada in 1956, at the time of the Hungarian Revolution. He worked in assorted blue-collar jobs in Thompson, Manitoba, before moving to Montreal and becoming a keyboardist in various rock

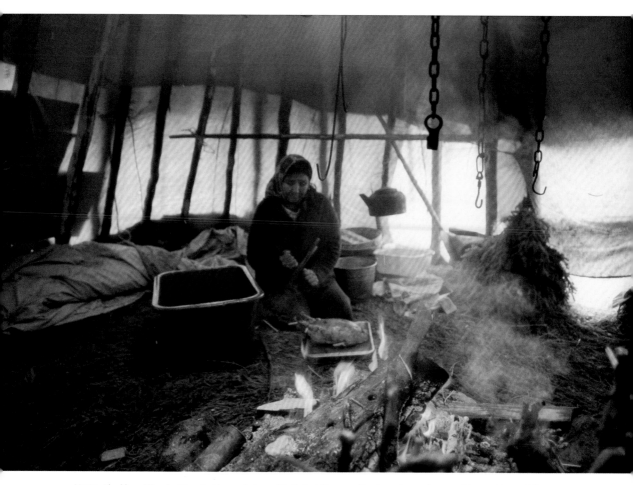

Nettie Blackboy (Cree), sitting inside a mitchuap (tipi), Fort George, Quebec, date unknown. (**George Legrady**)

bands. It was in Montreal, while a student at Loyola College, that he developed an interest in photography. In 1972, he received a grant to visit and photograph people in the James Bay region for the Quebec Métis and Non-Status Indian Association. The photographs featured here were taken in the summer of 1973 in Fort George, Eastmain, Wemindji and Rupert's House (now Waskaganish) at the invitation of Chief Billy Diamond, and were funded by a federal Opportunities

for Youth grant. His first visit predated the creation of the Grand Council of the Crees and the James Bay and Northern Quebec Agreement (JBNQA) of 1975.

"We contacted Billy Diamond, who was the Grand Chief and organizing the JBNQA negotiations, and we were welcomed [with the grant], so we got two male and two female photographers to go up [to James Bay]," Legrady recalled. "I was up there about twelve weeks. We started in Fort George, then Eastmain, then Wemindji, Rupert's House, and then back to Fort George. It was great to be up there. I was twenty-three then. We were given a tipi and we had to learn to chop wood with about a hundred people looking at us," he remembered with a laugh. "I'd never chopped wood before.

"You'd wake up in the morning. You'd have your camera, and whatever you'd do, with people or going places, you'd be continuously photographing. It was a casual but at the same time focused approach. Situations would come up that you had not planned and that allowed for very interesting results."

Legrady also spoke of the intimacy of the interactions, such as when he'd put the camera down and a member of the community would pick it up and start photographing. People in Legrady's age group, eighteen to twenty-three years, felt comfortable with the camera, he remembers, while the elders, who didn't speak English, were a little more reluctant and curious about what would be done with the images.

Legrady moved to San Francisco in the fall of 1974, where he completed a master's of fine arts in photography at the San Francisco Art Institute in 1976. He is the recipient of a prestigious John Simon Guggenheim Visual Arts Fellowship (2016) and a National Science Foundation Arctic Social Science Grant (2012), which funded the digitization of the photographs and two return trips to James Bay to present the photographs to the Cree communities. Since 2001, he has been a professor of media arts at the University of California, Santa Barbara, where he directs the Experimental Visualization Lab.

Photographer George Legrady,
Fort George, Quebec, 1973. (**George Legrady**)

Of his return to the James Bay region in 2012 to show the photographs, Legrady said, "Most of the people who came to my talks were elders. I think the young people were made to come, but they were less interested. People that I hadn't seen in a long time, like Gordon Neacappo and George Diamond, who is now health minister. It was emotional. It was amazing to see people you hadn't seen in forty years and be able to have that kind of connection."

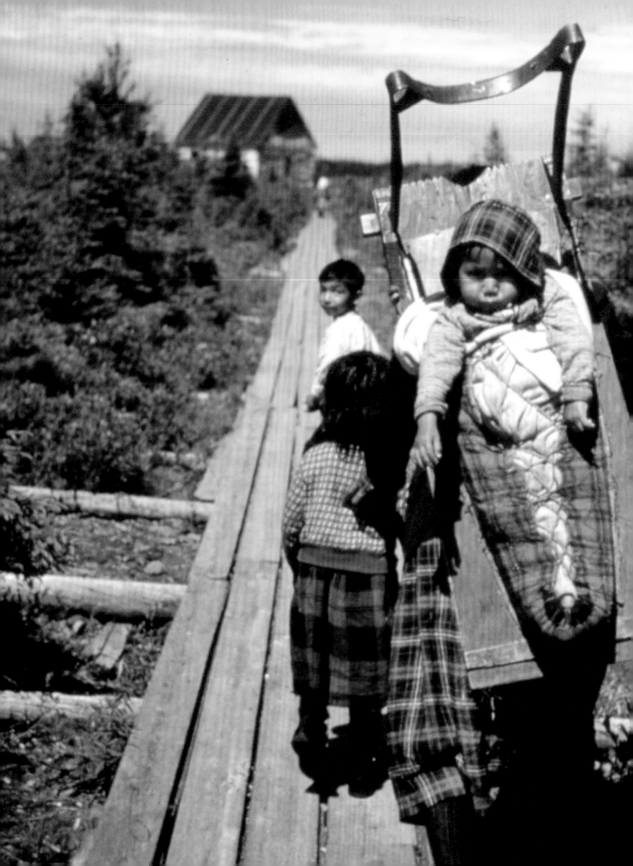

HUDSON BAY WATERSHED

The western Hudson Bay watershed, in what is now the province of Ontario, is a huge expanse encompassing the territories of the Cree (Anishini), Oji-Cree and Anishinaabe.

It is a land of hundreds of lakes and rivers, and transitions from boreal forest to muskeg to tundra, spread over more than 500,000 square kilometres. Traditionally, as Anishinaabe writer Basil Johnston relates in *Hudson Bay Watershed*,[1] Indigenous peoples adapted to the seasons—in summer gathering in large camps near lakes and rivers, and in winter in smaller camps where animals could be hunted and trapped.

It could be an unforgiving land in those days before the 911 system and satellite radio. Photographer John Macfie recounts the story of George Metatawabin, who, after an accident in the bush, amputated his own leg at the knee with a knife. He was two hundred kilometres up the Albany River and, after recovering in his cabin, resumed trapping that season, using bound-together snowshoes as crutches. Or there was Danny Tuckesin, who, with his legs paralyzed, went into the bush unassisted, canoeing and trapping. Of course, just as there were inspiring tales of perseverance and survival, so too were there stories of those who got lost in the wilderness, some never to be found again.

The James Bay Treaty (Treaty No. 9), one of the last numbered treaties signed in Canada, covers most of the area of the western Hudson Bay watershed that machines travelled. It was the only treaty in Canada signed by a province. It was first signed in 1905 and 1906 by the federal government, the Ontario government, and the Cree, Ojibway and Algonquin Nations of what is now northern and northwestern Ontario. The nations that signed in 1905–6 included those peoples occupying the area south of the Albany River. Signatures of the remaining Cree and Ojibway nations north of the Albany River were added in 1929 and 1930.

To this day, there is very little agreement among the treaty partners as to what Treaty 9 means. For the Cree, Oji-Cree and Anishinaabe of the area, the understanding was that the signed treaties guaranteed protection and assistance from a benevolent Crown as well as a perpetual land- and resource-sharing arrangement. At the heart of this agreement, as with other numbered treaties in Canada, was First Nations' assertion that they had never surrendered their land or their right to govern themselves. This belief would soon be contradicted by the implementation of the Indian Act and the residential school system, not to mention the wholesale exploitation of the land's resources.

In the late 1950s, when most of these photographs were taken, a semi-nomadic lifestyle persisted, trapping was still a viable way to live, and the sedentary enclosure of the reserve town was only in its infancy. At the heart of this way of life was the oral tradition and storytelling. Stories were told not only of legends and sacred things, but also of history. The treaty process included oral negotiations, but not only did many of the oral promises not make it into the signed treaties, they were also not recognized by the colonial authorities or the courts. The elders' oral records and traditions were discounted. This "miscommunication" continues to plague relations between First Nations and federal and provincial governments.

The Crown, however, saw the treaty process as a necessary step towards assimilation and the radical elimination of traditional lifestyles. Part of the rationale for the treaties was the desire of the federal and provincial governments to open parts of the region for development and resource extraction. Roads, railways, towns, logging and mining were the "way of the future." In this regard, Ontario and Canada viewed the written terms of Treaty 9 as a convenient carte blanche for the surrendering of most of 650,000 square kilometres of, in the colonial parlance, wilderness.

It is essential to grasp these two different visions of the region if one is not only to situate the Indigenous reality in the photographs that John Macfie took but also to understand the many crises that make headlines today: the continued court battles over land and treaty rights and their interpretation, as well as the tragic legacy of residential schools and issues such as youth suicide. Knowing the history of the region also puts into context the tragedy inherent in a place like Neskantaga, which faces the longest boil-water advisory in Canada, now over twenty years old.

IN 1949, WHILE WORKING AT OSNABURGH HOUSE, originally the site of a trading post on Lake St. Joseph, John Macfie, photographer and field worker with the Ontario Department of Lands and Forests, heard of a woman who reportedly lived an old-style, traditional lifestyle. He was told this "woman of the land" would come to Osnaburgh only once a month to pick up her old-age security benefit and sundry supplies at the local Hudson's Bay Company store. At the time in Osnaburgh, as in many remote northern villages, the HBC store was a place to buy goods as the local post office and the place to contact a doctor via radio.

Intrigued by the story of this woman, John Macfie (1925–2018) went to Lake St. Joseph to meet her on one of her trips into town. In the photographs he took that day, using his Zeiss Contax for colour slides and a Rolleicord for black and white, she is seen arriving with her grandson and also paddling up and down the shoreline. Her name, Macfie found out, was Maria Mikenak. Mikenak spoke no English, and Macfie spoke only a few words and phrases in Anishinaabe and Cree, so they communicated mostly through body gestures.

Maria Mikenak was Anishinaabe and lived largely on rabbits, fish, berries and manomim (wild rice) when it could be obtained. When he met her, Mikenak was probably in her late sixties. Her canoe was made of birchbark, well crafted and sturdy, and her paddle was also handmade, likely carved from spruce.

"At that time few people were making canoes anymore out of birchbark," Macfie told me. "They were mostly all replaced by commercial canoes, Chestnut canoes, which the Hudson's Bay Company handled and sold, made in New Brunswick." Mikenak's canoe was entirely of her own making, with patchworks and repairs added from time to time. "I noticed one spot where she had repaired a tear with a wire nail or two and some cotton twine," he said.

Maria Mikenak, arriving with her grandson (Anishinaabe), Lake St. Joseph, Ontario, 1956. (**John Macfie**)

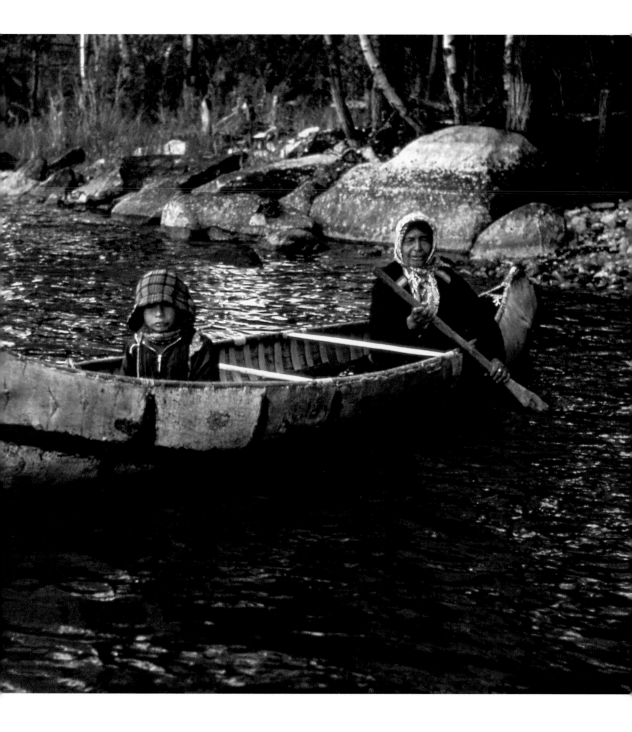

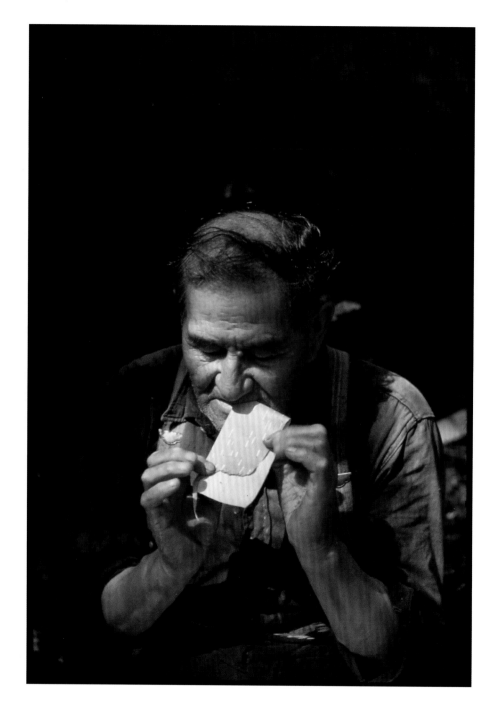

Macfie moved to another part of Ontario soon after, and never saw or heard of Maria Mikenak again. Presumably, she went on living off the land—harvesting, snaring, fishing or hunting the foods she needed. And using her skills, making and repairing what she had built from the resources offered by the land.

WILLIAM MOORE WAS CREE and originally from Moose Factory, Ontario. Moore was determined to preserve the old ways as much as possible and made everything himself, from wooden bow drills for making fire, to spruce paddles, birchbark baskets, and ladles. He foraged from the land. He also made crafts and games. Moore often eschewed items he could have bought in a store, preferring to make his own versions. He also practised traditional arts, one of which, as seen in the John Macfie photograph, was birchbark biting art.

In birchbark biting art, intricate designs such as turtles, hummingbirds or bees are made by biting on the folded strip of the inner bark. It takes much practice to learn what folds and pattern of tooth bites create which design. There is no use of brush or pencil to draw an outline; it is done from memory. The bark is first peeled until you have an almost onion-skin layer of birchbark. Then the birchbark is folded in different ways, similar to paper doll cut-outs, and bitten upon to create the design. The art form was dying out at this time, and William Moore and Angelique Merasty, in Saskatchewan, were two of the very few practitioners keeping it alive.

"I went with Moore on a material-gathering expedition one day," recalled Macfie. "Gathering birchbark and assorted wood to make wooden spoons from, and spruce roots to sew baskets with."

The birchbark was best harvested in June, when the tree's growing activity peaks. Not every tree yields usable bark, but Moore had an expert eye for selecting the right kind of tree for his needs. To obtain pliable sewing material, Moore stripped the thin but extremely strong bark from a shrub he called chebaygoop, or ghost leaf, then stitched the layers together to make baskets. The scientific name

William Moore (Cree), making birch bark art,
Mattagami First Nation, 1958. (John Macfie)

for chebaygoop is *Dirca palustris*; a common name for it is leatherwood. The shrub is found only about as far north as Mattagami, but Moore knew exactly where to locate some. The bark of the plant was also brewed and used as a medicine.

Also a storyteller and knowledge keeper, William Moore knew the locations of pictograph sites, the stories of the land, as well as where to find the small "doorways" in cliffs where the mischievous mamakwayseeuk, or little people, lived.

He was also a very independent man, Macfie recalls. One day, when he felt unwell, he told Macfie he was going to see a doctor in Timmins. Macfie asked him how he intended to get there. Moore told him by canoe. Moore paddled down the Mattagami River, along the length of Kenogamissi Lake, a total canoe trip of sixty kilometres, then hitched a ride on a logging truck the remainder of the way.

IN THE SPRING OF 1956, JOHN MACFIE was at Round Lake (Weagamow). Families that had been living off the land since the fall, on trapping grounds where they went year after year, returned to Round Lake. It was a time of reconnection, gathering and celebration. Dances were held, with fiddle players providing music. In the winter, in the bush, the Cree and Oji-Cree trapped, and ate mainly rabbits and fish, but occasionally they might get a moose or, even rarer, a caribou. Although the families' wintering grounds were loosely defined, they did become the framework for the provincial government's registered trapline system. It was Macfie's job during this coming together, working for the Department of Lands and Forests, to register the trappers and their lines, keeping a record of beaver lodges in each region and how many pelts had been harvested.

In the late 1950s, this semi-nomadic lifestyle was still going on, though modern society in the towns and the residential school system were having a detrimental effect on families and the traditional way of life.

"I used to carry cameras and take pictures of interesting things," Macfie said. "I guess I was a bit like Willie Moore—I was always interested in the old ways. On one of those days I came across this [Cree or Oji-Cree] girl by a smoke lodge where they were smoking a moosehide." He took colour and black-and-white photos of her, both inside and outside the smoking lodge, though any notes he had of her name or family are long gone.

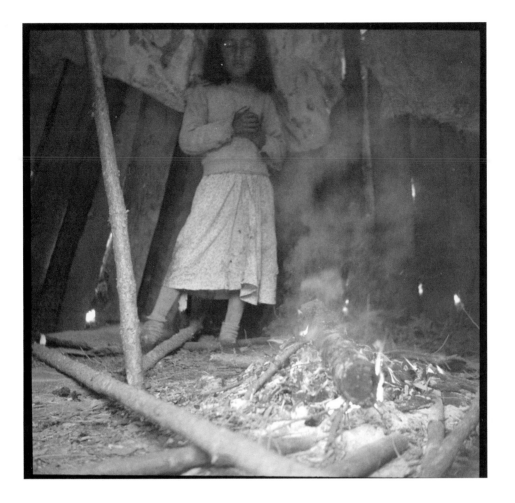

Girl by a small lodge, smoking a moosehide,
Weagamow First Nation, 1956. (**John Macfie**)

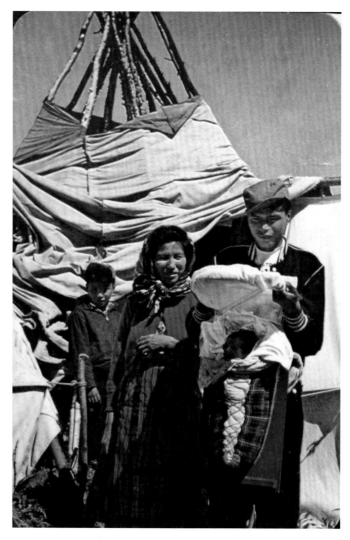

Lizzie (left centre) and Solomon Suganaqueb and family (Anishinaabe),
Neskantaga, Ontario, 1956. (**John Macfie**)

"Those ten years in the North gave me a unique opportunity to see and photograph
[Indigenous] people going about daily life in a wide range of environments, from
trackside settlements to the windswept tundra bordering Hudson Bay."
–JOHN MACFIE

Caribou hides were smoked in one piece because they were lighter and smaller. Moosehides were always split down the backbone into two pieces to make them easier to scrape and tan. A single moosehide was much too heavy for the women and older girls who had to stretch it, soak it in water and wring it out. "It was too big, like [having to] manage a great big floor rug. So they cut them in two, that's why there are two pieces [in the photograph]," said Macfie.

The hide was soaked for three days to loosen the flesh and hair, then draped over a log or heavy pole. A wet moosehide can easily weigh fifty kilos, so it was not an easy task. Once the hide was reasonably clean, holes were made on the outside edge so the hide could be tied to a large pole stretcher. Then it was left for a few days to dry.

Once dry, the softening process began. A fleshing tool was used to scrape the hide. This was hard work, often taking days. The more scraping, the softer the hide. Then the hide was removed from the frame and rinsed to remove all the blood, and hung over the frame again to dry. Next, the hide was immersed in water and yet again hung to dry. Cooked brain, which has the right amount of fat in it to soften the hide, was then worked into the hide. At this stage, the hide is a creamy colour, and in this form it is often used for ceremonial regalia.

The moosehide tanning could be considered complete at this point, but usually the next step was to smoke it. Hot coals that will produce only smoke and no flame-out were used, or old spruce wood that gives the hide a nice golden colour. Occasionally dry pine cones were added to lend a reddish tinge. The hide was smoked for at least four or five hours, to achieve an even colour. Once the colour was right, the hide was rolled up and smoked again overnight. Finally, in the morning, the hide was unrolled and stretched outside to air.

This 1956 photograph (opposite) is of the Suganaqueb family (Anishinaabe), who travelled by canoe over a hundred kilometres from Webequie for Treaty Days at Neskantaga (then Lansdowne House), Ontario. Dozens of families made the spring trip from the "fly-in" community, setting up a temporary village of canvas tents that dotted the land. It was the annual "treaty time"; there would be the treaty party, plus an X-ray machine, X-ray crew and doctor—at that time TB was still rife. The Indian agent and a Mountie in red serge would also be present for the ritual of the treaty payment of five dollars.

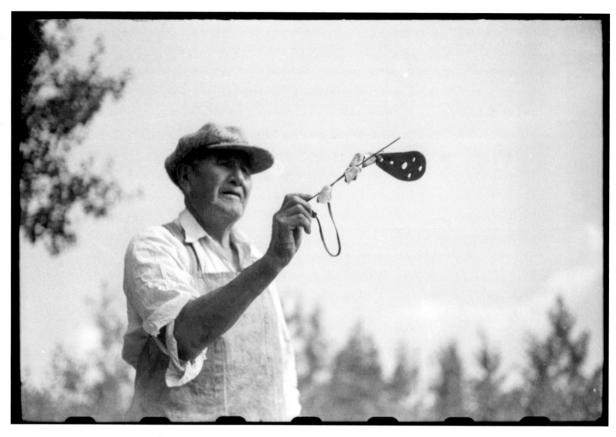

William Moore (Cree) playing nabahon, Northern Ontario, 1957. (**John Macfie**)

William Moore made a ring-and-pin game called nabahon.
The game was a test of skill and practice. Moore made the rings from the
knucklebones of a moose's cloved hooves. A small hole was drilled through
the five pieces, which were then strung on a piece of tan moosehide and
finished with the pin, made from wire, though traditionally, Moore told
Macfie, the wire was made from a lynx's leg bone. The game involved
swinging the five rings upward and outward and then skewering as many
as possible with the wire while they were airborne.

"Everybody came," Macfie recalled. "Parents, grandparents and children. The kids could expect a treat that day from the Hudson's Bay Company store. Sometimes oranges were given out."

Once each summer, a "treaty party" visited all the larger communities lying within Treaty 9, a vast territory covering most of present-day northwestern Ontario. Band members living in satellite settlements, like the Suganaquebs of Webequie, canoed in and set up camp, or moved in with relations for a week or more. In addition to the central business of treaty time, this was an occasion for reconnecting with family and friends, and indulging in community events. At Neskantaga, this invariably included one or more square dances, with local fiddlers and guitar players taking turns providing the music. All this was in fact a continuation of annual festivities that predated contact and colonization.

"So a little canvas colony of people from Webequie sprang up each spring, and I went there and took many pictures that day," Macfie said. "I also did my trappers' meeting for the trappers in that area at the time."

There were many hundreds of licensed trappers in Macfie's area of responsibility, which reached all the way from Sioux Lookout on the transcontinental railway north to Hudson Bay. However, at trappers' meetings he dealt mostly with the head trapper in each family group, as trapping on the traditional wintering grounds was a co-operative affair. It was a matter of recording how many moose had been shot, as well as how many animal pelts and what kind had been trapped. This was all tallied and then quotas were issued for the next year. Some species of fur-bearers experienced pronounced cycles in abundance. At mid-century, for example, marten were nearly exterminated. In a few years they came back and, in Macfie's words, "were as common as red squirrels."

These were the waning years of snowshoes and dog teams and sleds. Snowmobiles had not yet become common in the North, and the trapping lines were still maintained in the way they had been for generations. It was a time when trapping could still provide an important source of income for Indigenous families living close to the land.

In a generation, all of this would change. There would be snowmobiles, houses, television and a more sedentary lifestyle for most. The animal rights movement

and anti-fur sentiments would decimate the livelihood of Indigenous trappers. Ironically, this movement arose from the very colonial markets that had first driven the desire for North American furs.

In 1950, the Department of Lands and Forests expanded operations in northern Ontario, following the signing of an agreement between the Ontario and federal governments to manage and preserve the wild fur reserves in the region. John Macfie was hired at that time as a trapline management officer working out of Sioux Lookout, Ontario. Originally from Dunchurch, Ontario, Macfie had started his career in the department a year earlier, when he was hired as a ranger and apprentice log scaler. As a trapline manager, he travelled the North, resolved trapline boundary disputes, audited beaver lodge counts, and monitored wildlife abundance and habitats.

His job enabled Macfie to combine his government work with his personal interest in photography. During the ten years he worked in the North, he often carried cameras with him on field trips, where he photographed Indigenous people in settlements and living a traditional lifestyle on the land, and also annual events such as Treaty Days. He took his photographs in colour and in black and white. In 1960, Macfie returned to Parry Sound, where he continued working with the Ontario Department of Lands and Forests as a senior conservation officer in the Fish and Wildlife Division. During this time, he returned briefly to the North to work on aerial counting of polar bears in 1963 and 1964 in the Attawapiskat area.

In 1972, Macfie became supervisor of the Fish and Wildlife Branch, Parry Sound District, a position he held until his retirement in 1981. Following his retirement, Macfie published *Now and Then: More Footnotes to Parry Sound History* (1985), *Hudson Bay Watershed: A Photographic Memoir of the Ojibway, Cree and Oji-Cree* (with Basil Johnston, 1991) and *Tales from Another Time: Oral History of Early Times in Parry Sound District* (2000), among many others. In his lifetime, Macfie published more than thirteen books, and always retained a deep interest in the James and Hudson Bay coasts.

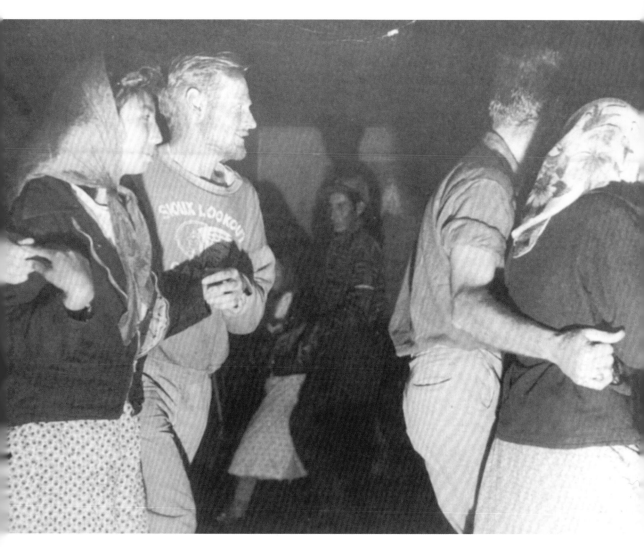

Photographer John Macfie (left) dancing with Sally Miles at Fort Severn, Ontario, date unknown. (**George Arthur**)

LAND OF
THE BISON

SASKATCHEWAN, MONTANA AND ALBERTA

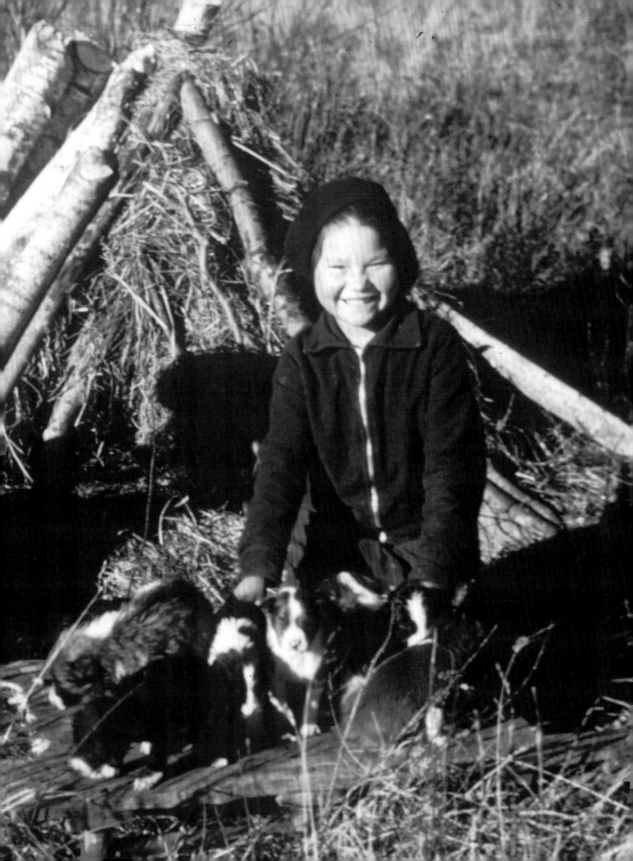

SASKATCHEWAN

By 1870, the bison herds were gone from what is now central and southern Saskatchewan. Their decline was due to overhunting by settlers moving west and deliberate government policy.

For the Indigenous peoples who had relied on the bison for centuries, it ushered in a desperate time of near starvation and hardship. The decimation of what had been a bountiful resource was a result of colonial expansion on the western Plains of both the United States and Canada, and was part of the policy of manifest destiny. Coupled with periodic outbreaks of smallpox, against which the Plains tribes had no immunity, the conditions greatly weakened the strong and vibrant alliance of Indigenous peoples in the area.[1]

For nearly a century the Iron Confederacy, a political and military alliance of Cree and Assiniboine, later joined by Saulteaux, some Lakoda and Metis, maintained a monopoly over the profits of the fur trade with the Hudson's Bay Company on the Prairies, and expanded westward over the northern Prairies. By 1850, the Iron Confederacy was at its apogee, effectively controlling a vast swath of land that is now Montana and Alberta, having pushed the Blackfoot Confederacy westward, to the boreal forests of the North, and to posts such as Fort Edmonton and Fort Pitt.

By the time the Canadian government bought the HBC's land in the West in 1869, the bison herds had ceased to come into what is now Saskatchewan. Cree and Assiniboine bands were forced to travel farther south and west, across the US border, in search of the last herds, while whisky traders and wolfers[2] brought their destructive trade north, with the establishment of Fort Whoop-Up in southern Alberta in 1869.[3] Treaties 4 (1874) and 6 (1876), which encompassed much of Saskatchewan, must be viewed within this context of the disappearance of the bison, the encroachment of illicit traders and the necessity of adapting to a new, harsh reality.

The Cypress Hills massacre in June 1873, when more than twenty Assiniboine men, women and children were killed by a gang of wolfers, sparked the Canadian government into action to bring "order" to the Northwest and assert Canadian sovereignty. When news of the massacre reached the East, it spurred anti-American sentiment in the press and a call for action; that some of the perpetrators of the killings were Canadian was conveniently overlooked. The North-West Mounted Police were dispatched to the region.

The treaties were a prerequisite for the completion of the transcontinental railway and to "free up" land for settlement, both major goals of John A. Macdonald's

government. According to the two treaties, in exchange for relinquishing owner-ship of land, each band was to receive, per family of five, one square mile of land, and each band member would be given a treaty payment of five dollars a year and a gift of clothing. Cree chief Big Bear had lobbied for a shared reserve in the Cypress Hills, something the Macdonald government rejected on the grounds that they didn't want the various bands united and didn't want the Plains Cree so close to the American border, where they might be perceived as a threat. Upon signing the treaty, each chief was given twenty-five dollars as well as a treaty coat, a silver medal and the promise of twenty-five additional dollars annually. Band members were also to receive farming tools, portioned by family, and powder, shot, ball and twine. Schools were also promised on each reserve, as well as the right to hunt and fish on ceded (Crown) land, so long as it wasn't already taken by settlers. The treaties were supposed to last forever. As we shall see, rather than re-ceiving educational centres, Indigenous peoples would soon be subjected to the infamous residential school system.

The Indian Act of 1876 gave the Canadian government sole authority to deter-mine relations pertaining to "Indians and Lands Reserved for Indians." The Act governed every aspect of life for First Nations people on reserves. It was patriarchal and sexist. For example, when an Indigenous woman married a non-Indigenous man, as defined by the Act, she lost her "status," including the ability to live on the reserve, as did her children. Non-Indigenous women who married Indigenous men, again as defined by the Act, gained status. This overriding legislation played havoc with traditional forms of governance, as well as minimizing the rights of women.

The Act imposed upon First Nations communities a paternalistic system of control whose ultimate goal was termination of First Nations' rights and assimila-tion into Canadian society. On the reserves, the Indian agent, a non–First Nations bureaucrat, was all-powerful.

After the cataclysmic events of the 1885 Northwest Resistance, and the disen-franchisement of the Metis, a pass system was implemented. First Nations adults had to apply for a "pass" simply to leave the reserve, or a "permit" to purchase or trade goods. Initially drawn up to deal with "rebel Indians" after 1885, the pass system was soon in force in much of treaty country, its enforcement heaviest on

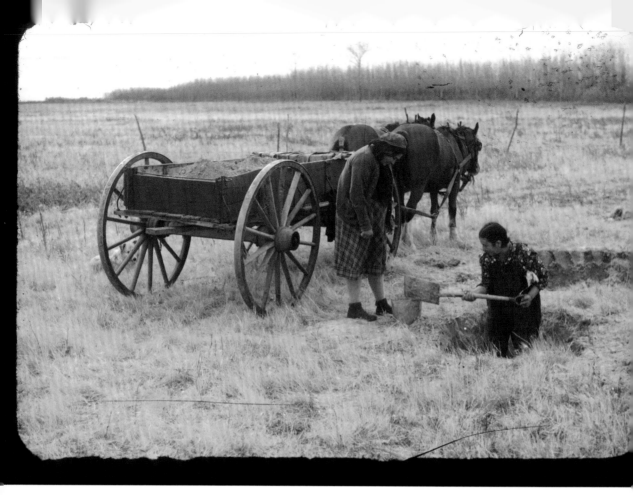

Cree women digging clay, Duck Lake, Saskatchewan, 1944. (**Everett Baker**)

the Prairies. The pass system, while lessening after World War II, would remain in effect on some reserves on the Prairies until the early 1960s.

There was still an opportunity in the early 1880s for the Canadian government to fulfill its obligations under the treaties, in particular by supplying farming equipment. If the Canadian government had responded in good faith to the concerns of the Metis, under the leadership of Louis Riel, whom they had just summoned back from Montana, and the Cree and other First Nations, who were lobbying with the British Crown, the cataclysmic events of 1885 might have been avoided. Tragically, all these efforts would fall on deaf ears in Ottawa.

A WOMAN STANDS THIGH-DEEP IN A HOLE dug in a field, shovelling clay into a bucket, as another middle-aged woman stands over her, waiting to dump the full pail into the almost-full wagon. A team of horses waits and a dog kneels in the grass behind a rear wagon wheel. The clay will be mixed with wood ash or grass and water to chink someone's log cabin on the Willow Cree reserve of Beardy and Okemasis, near Duck Lake, Saskatchewan.

The year is 1944, the war is still raging in Europe, and many young Cree men are serving overseas. These two women are no doubt used to hard work, even more so now that so many men are away. They have known hard times, growing up in the 1920s and '30s, through the Great Depression, when the Prairies were turned into a dust bowl and so many farmers lost their homesteads. On the reserve, times were no less hard, but people pulled together, sharing the work and what little bounty there was so that no one starved. The look on the women's faces is not one of sadness; rather, they appear to be enjoying their labour and each other's company.

The photograph could as easily be a naturalist painting by the Cree artist Allen Sapp, who was born in the winter of 1928 on the Red Pheasant reserve. Sapp would have been a teenager at the time Everett Baker took this photograph, but it was images such as these two women that the impressionable teenager held in his memory and later turned into the subject matter for his many paintings. As a child, Sapp was frequently sick. His mother was also often ill, and would eventually die of tuberculosis. Sapp was then raised and cared for by his Kokum (grandmother), Maggie Soonias. When he was eight and again ill, Maggie Soonias had a dream in which she saw her grandson facing death. She went to the bedridden child and, touching him, gave Sapp his spirit name, Kiskayetum (He Perceives It). Sapp would survive.

Sapp's paintings captured day-to-day life on Cree reserves in the 1940s and '50s, a time before running water or television, when wagons far outnumbered trucks, and when the local entertainment was often a community hall where fiddlers and guitarists would play by the light of hung kerosene lamps, as people jigged and danced reels. Sapp was self-taught and painted all the seasons and their associated activities, from hauling logs through birch trees on a horse-drawn sled in winter to harvesting crops in the blazing prairie summer to children at play and powwows. Working together was just the way you got things done.

FAIRS IN NEIGHBOURING TOWNS AND CITIES were a big deal for Indigenous people on the Prairies in the 1940s and '50s. It was a chance to hitch up the wagon, load the whole family, along with items to sell or trade, and head into town. At a time when the Indian agent still controlled much of reserve life, and the pass system, designed to keep "Indians on the reserve," was enforced, the chance to travel off-reserve was very welcome.

Events like the North Battleford fair attracted wagonloads of families from neighbouring reserves. In the Battleford area, mostly Cree, Dakota, and Metis came to the fairs to trade and buy goods, see the attractions, and, most importantly, socialize with relatives and friends and catch up on happenings at a time when the dominant mode of communication was still word of mouth.

This photograph was taken the day after the fair. The teams of horses are now hitched up; people, dressed in their Sunday best, are saying their final goodbyes to relations and friends from neighbouring reserves, making last-minute exchanges of goods and preparing for the long journey "back to the rez." These fair get-togethers also echo the old times, when smaller bands would come together during the warm months, at special places, for ceremonies, trading and dancing.

One of these gathering places was the valley of the Opimihaw Creek, near Saskatoon, where the creek feeds into the South Saskatchewan River. Recent archaeological digs have found stone cairns, pottery fragments, tipi rings, tools, eggshell fragments, arrowheads and animal bones that predate the building of the Egyptian pyramids. The Wolf Willow dig at Wanuskewin has found artifacts that date back about five thousand years, including a five-hundred-year-old, highly polished elk tooth that was part of a beautiful amulet worn by a woman.

Before the first horses arrived on the Plains, Wanuskewin was the site of buffalo jumps, which were a meticulously planned stampeding and funnelling of bison over the steep slopes of the Opimihaw valley. A successful hunt would feed and clothe a tribe for the year. Once horses arrived on the northern Plains in the early 1700s, the days of the buffalo jump ended, as the Plains tribes quickly adopted the horse, but places like Wanuskewin remained annual gathering places where bands came together in the summer and held both social and ceremonial celebrations.

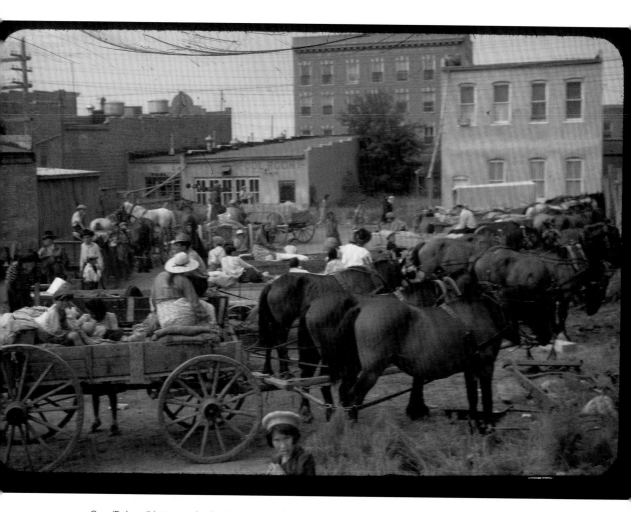

Cree/Dakota/Metis people, the day after the fair, North Battleford, Saskatchewan, 1945. (**Everett Baker**)

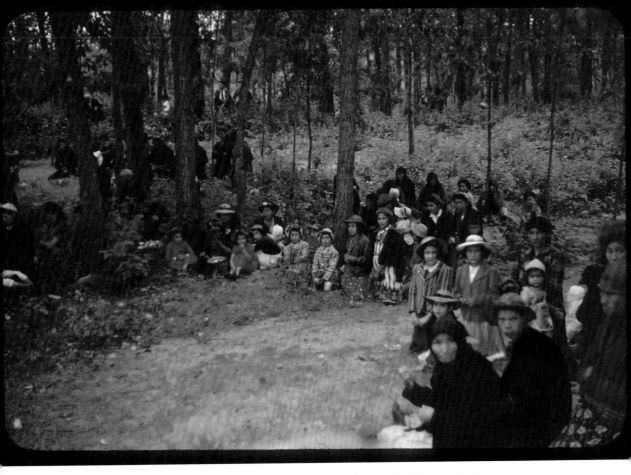

St. Laurent pilgrimage (Cree/Metis) near Duck Lake, 1944. (**Everett Baker**)

Everett Baker's photograph of the North Battleford fair in 1945 shows that the desire of the people to congregate, trade and celebrate together was not extinguished, even after seventy years of living under the reserve system, and dealing with the restrictive bureaucracy of the Indian Act and the Indian agent.

ST. LAURENT DE GRANDIN IS AN AREA OF METIS SETTLEMENT along the banks of the winding South Saskatchewan River. It is downstream from the Metis village of Batoche and was part of the south branch settlements of the Metis that were established in the 1870s. The aspen woods bordering the South Saskatchewan River here had long been associated with the Cree and Metis, who, in the buffalo

days, had winter camps in the region. But the area had been a gathering place prior to the Metis, as attested by bison jumps and archaeological findings. The sacredness of the aspen parkland along the river in that area was clearly evident to people long before the first buildings were constructed.

Following the Canadian government's suppression of the provisional government of Louis Riel in 1870, more displaced Metis from Manitoba arrived in the region. A mission was established in 1873, and within a decade St. Laurent, like the neighbouring village of Batoche, was a prosperous village with a telegraph, a post office, stores, a ferry and a mission. The site of a nearby spring had long been a place of prayer for the Cree before the Metis came and was known for its healing properties. It was here that a shrine was established in 1881, with the addition of a grotto the following year.

During the fighting between the local Metis communities and the Canadian military, the site served as a refuge for women, children and elders. The cemetery also became the final resting place of several local Metis killed during the battle of Batoche. Following the tumultuous events of the 1885 resistance, Charles Nolin, a prominent Metis leader in the community, whose wife was suffering a mysterious stomach ailment and internal bleeding, asked the local Fathers for help. The Fathers suggested she pray at the nearby spring, recently dedicated to Our Lady of Lourdes. There she was cured, and Nolin promised to pay for a statue at the site.

Abandoned after 1885, the site slowly regained its status as a spiritual sanctuary for the Metis, Cree and Fransaskois (Franco-Saskatchewanians) peoples in the difficult decades following the Northwest resistance, the implementation of residential schools and the disenfranchisement of the Metis. The first pilgrimage to the grotto took place in 1905, and at its height, in the 1940s, hundreds made the annual pilgrimage for blessings and the reception of healing miracles. Crutches and wheelchairs were left at the grotto, a symbolic tribute to the miracles that had occurred there.

The dark history of residential schools, and the countless instances of abuse inflicted upon students, naturally casts a long shadow over the relationship between the Church and Indigenous communities. But faith is deep-rooted and complex, and while the intentions of those seeking to "save and convert" were no doubt rooted

in the denial of Indigenous beliefs and inspired by the misguided conviction of the missionaries and priests of the time that Christianity would be a saving and civilizing grace, it is also a fact that an unintended blending of faiths could and did occur.

IN 1903, FATHER HUGONARD, principal of the Qu'Appelle Indian Industrial School, wrote the first of many letters to Indian Commissioner David Laird, complaining about "Pow-Wows" as "the hotbed of Indian ways, laziness, and discord," and suggesting that Indian agents penalize "known dancers." Sections of the Indian Act were designed to suppress traditional ceremonies and spirituality, such as the sun dance and potlatches, but secular gatherings such as powwows were also discouraged and even banned.

> *Every Indian or other person who engages in, or assists in celebrating or encourages either directly or indirectly another to celebrate, any Indian festival, dance or other ceremony of which the giving away or paying or giving back of money, goods, or articles of any sort forms a part, or is a feature, whether such gift of money, goods or articles takes place before, at, or after the celebration of the same, and every Indian or other person who engages or assists in any celebration or dance of which the wounding or mutilation of the dead or living body of any human being or animal forms a part or is a feature, is guilty of an indictable offense.*[4]

Still, these gatherings continued to take place either in secret or under the auspices of an Indian agent who chose to look the other way and ignore policy in certain areas. Dancers who had been penalized would often find themselves gifted[5] at the powwows by other participants as the communities found ways to subvert the control of the agents.

It is believed that the Dakota people brought the first powwow dances across the Medicine Line (the Canada–US border) into what is now Saskatchewan, and they were soon adopted across the Prairies as a means of celebration. Over time the dances evolved, as did the music and the regalia, the costumes becoming more elaborate for both men and women. Originally primarily a men's dance, gradually

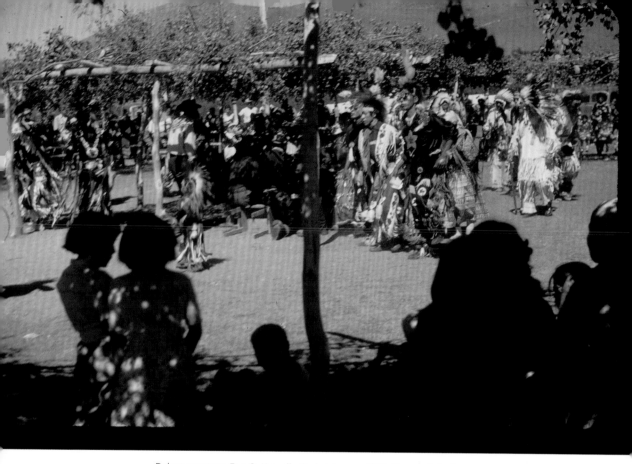

Dakota powwow, Fort Qu'Appelle, Saskatchewan, 1957. (**Everett Baker**)

women participated more and developed their own styles of dance. Through the decades of suppression, and the destabilizing impact of residential schools, the pow-wows continued, albeit less frequently and without official sanction. It wasn't until 1951 that the Indian Act was amended so that powwows could be held without interference or penalty, and it was not long after this change that Everett Baker visited the Qu'Appelle Valley and took photographs of the "Sioux" (Dakota) powwow.

Under a log-and-grass canopy, the dancers circle the spectators. Their regalia is bright and colourful and bears the markings of what would be the pageantry of contemporary powwow dress. There are no number cards visible on any of the dancers, so this is likely a "traditional" (non-competitive) powwow rather than a "competitive" (prizes) gathering. The delicious irony is that this 1957 dance is

taking place not far from where Father Hugonard lobbied to have the powwows banned just over fifty years earlier.

EVERETT BAKER (1893–1970) CAME TO SASKATCHEWAN after World War II. Working as a book agent, selling books farm to farm, he travelled extensively and saw much of the province. But it was after he bought a $100 Leica camera from a German immigrant that his invaluable contribution to the photographic history of Saskatchewan began. Working next as a field man for the Saskatchewan Wheat Pool, Baker took thousands of Kodachrome photos of farmers, townspeople and Indigenous peoples, capturing their day-to-day lives from the 1940s to the 1960s. He became a travelling roadshow performer of sorts, as people flocked to see his slides and movies on a portable screen, issuing from a projector that was powered by a portable motor in the back of his car.

According to former Saskatchewan History and Folklore Society executive director Finn Anderson, Everett was "intrigued by what life was like for the original inhabitants of the area, and spent considerable time and effort in meeting and learning from old-timers and elders throughout the province . . . What was intended to be a series of books . . . demonstrates Everett Baker's keen interest in our heritage and the important role that Aboriginal peoples played in defining who we are as a province."

In 1957, Baker became the founding president of the Saskatchewan History and Folklore Society. Shortly before his death, Baker donated his eleven thousand slides to the public archives, wanting them to be available to the public as he had always desired.

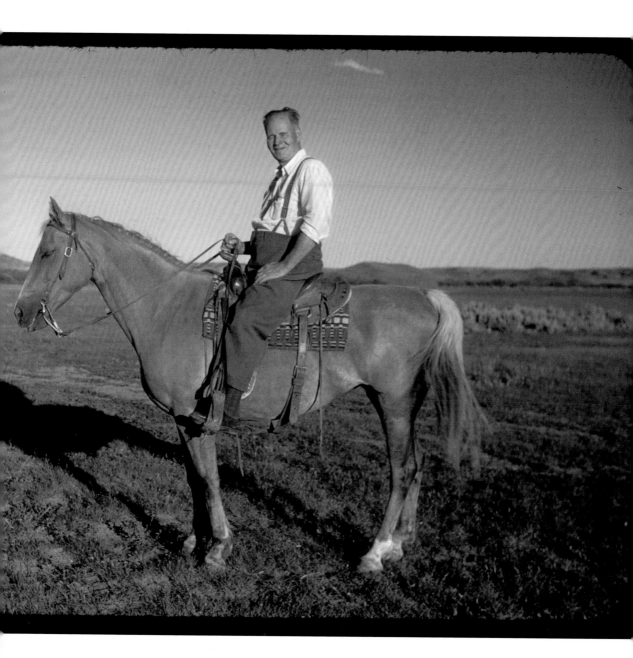

Everett Baker on horseback,
Val Marie, Saskatchewan, 1957.

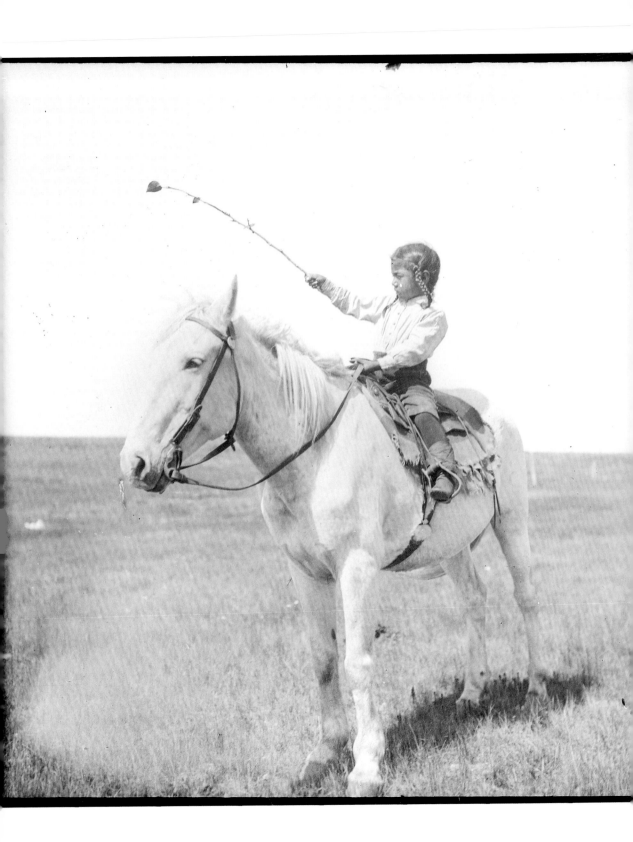

MONTANA AND ALBERTA

During the daylight hours of July 26, 1806, two parties encountered each other in the Marias River region of what is now Montana: one a group of eight Blackfeet teens, herding some horses,

and the other group part of the Lewis and Clark expedition. Meriwether Lewis and William Clark had been charged by President Thomas Jefferson in 1804 with exploring the vast lands recently acquired in the Louisiana Purchase from Napoleon Bonaparte's France. The area was defined by the drainage of the Missouri/ Mississippi river complex.

By all accounts, after initial wariness, the two diverse parties got along well, reportedly even having some horse races, engaging in a bit of gambling and sharing a meal. Lewis told the teens the expedition had already traded some guns with other tribes, which certainly would have been received as a threat by the Blackfeet party, and also told the boys that this land, along with the Sweet Grass Hills, the Bear Paws, Cypress Hills, Old Man on His Back Hills, all of it in Blackfeet country, now belonged to the United States. This statement would have struck the youth as a provocative insult.

According to Blackfeet oral history and the journals of the expedition, at dawn or shortly before, the youths rose and attempted to steal a few guns, which, if successful, would have been a big coup. Instead, Lewis shot one of the youths dead and another was stabbed to death. The remaining six fled on horses stolen from the expedition. For some reason, Lewis placed a medallion on one of the dead boys. His motives are unknown, but his action was later interpreted as a grave insult when the Blackfeet found the two bodies.

The expedition then took the remaining horses and rode pell-mell for the safety of Great Falls, a distance of around 160 kilometres, not stopping till they got there, a pace that almost certainly would have killed the horses. Lewis's decision to explore the Marias River region without any diplomatic overture was certainly reckless, and the end result was that Blackfeet country was a no-go region for whites, whether gold seekers, wolfers or settlers, for decades afterwards. Those whites who chose to risk it had a tendency to disappear.

COMPRISING THE NORTH AND SOUTH PIEGAN, the Kanai and the Siksika, the Blackfoot Confederacy have lived on the northern plains bordering the Rocky Mountains for more than thirteen thousand years. It is a vast territory of over 11 million hectares, stretching from the Yellowstone River in southern Montana

to what is now Edmonton, Alberta, in the north, and Saskatchewan to the west. The plains and foothills of the Rockies was a land that provided abundance for thousands of years. Numerous bison herds roamed the region, shaping the culture of the Blackfeet bands, which not only relied on the bison for subsistence but built a lifestyle around them, long before the first horses arrived in the early 1700s.

The Treaty of 1818, signed between the United Kingdom and the United States in faraway London, England, effectively drew a line along the forty-ninth parallel, not only separating two colonizing nations but also cutting in half the territories of many First Nations, including the Blackfeet. Similarly, there was no Indigenous representation, no Indigenous agreement, when Canadian government negotiators met with the HBC directorship in London in the winter of 1868–69. It was as if the vast territory known as Rupert's Land was devoid of people. The Blackfoot Confederacy, like the Crees and the Assiniboines and others, had no idea their land was being passed from one colonial entity to another.

North of the border, after some delays waiting on different chiefs and bands to arrive, Treaty 7 was negotiated beginning on September 19, 1877, by five nations: the Siksika, Blood, Piikani, Stoney Nakota and Sarcee. David Laird, lieutenant-governor of the North-West Territories, stated that the treaty would include the passing of laws to protect the remaining buffalo, putting an end to the illicit whisky trade, and the provision of ample supplies and equipment to enable the Blackfoot to transition to an agricultural life. Reserve land, treaty payments and education were also discussed and promised. Chief Crowfoot (Siksika) told the commissioners that nothing could go forward until Chief Red Cloud (Blood) arrived, which happened on September 21. While there was hesitancy and caution on the part of the Blackfoot leadership, their options were limited, and on September 22 consensus was reached. As many subsequent historians have pointed out, what the Blackfoot understood to be in the terms of the treaty, including the right to hunt on their lands outside the designated reserve, was quite different from what was written on paper by the treaty commissioners. As is often the case, the translation from oral negotiation to paper document left much to be desired. It would not be long before the Blackfoot Confederacy realized how fraught the process was.

In 1977, Bill Heavy Runner of the Blood Reserve commented, "The promises that were made to us started to disappear such as horses. Even studs were issued, cattle were issued. All these promises started to disappear . . . Today there are not too many people that know that when the sun burns out, when the river stops flowing, that is how long the words [promises] were supposed to last. That is what the Tall White Man [David Laird] based his promises on."[1]

South of the forty-ninth, the Blackfeet were not even present for the Fort Laramie Treaty of 1851, so had no idea that their territory was already being determined and parcelled out by the American government. In 1853, Congress approved money to explore and survey a route for the transcontinental railway. Isaac I. Stevens, recently appointed governor of the Washington territories that encompassed Blackfeet lands, was given the task of obtaining peace treaties with tribes along the path, including the Blackfeet, who had effectively closed off their territory to whites since the murders of the two teens in 1806.

Alexander Culbertson, a factor who had married a Blood woman, Natawista (Medicine Snake Woman), the daughter of Blood chief Two Suns, was made Stevens's special agent. On September 21, 1853, the Stevens party met with the Blackfeet. Notes of the meeting written by Stevens bear repeating, if only to illustrate the richness of Blackfeet culture at this time and how the Blackfeet must have perceived their rather shoddily dressed counterparts.

> On the 21st we held our talk with the Blackfeet. The chiefs and warriors were all richly caparisoned. Their dresses of softly prepared skins of deer, elk, or antelope were elegantly ornamented with bead-work. These are made by their women, and some must have occupied many months in making. The other articles of their costume were leggings made of buffalo skins, and moccasins, also embroidered, and a breech-cloth of blue cloth. Their arms were the Northwest guns, and bows and arrows. On all solemn occasions, when I met the Indians on my route, they were arrayed with the utmost care. My duties in the field did not allow the same attention on my part, and the Indians sometimes complained of this, saying, "We dress up to receive you, and why do you not wear the dress of a chief?"[2]

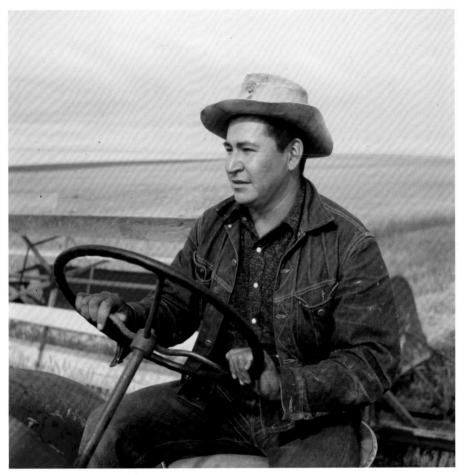

Cecil John Crowfoot (Siksika), farming, Siksika, Alberta, 1957. (**Rosemary Eaton**)

Cecil John Crowfoot was a successful farmer
on the Siksika First Nation in Alberta and the great-grandson
of the famous Blackfoot chief Crowfoot (Isapo-Muxika).

On October 17, 1855, at the mouth of the Judith River, the Lame Bull Treaty was signed. The Blackfeet were there, as well as councils from the Flathead, Pend d'Oreille and Nez Perce. There was even a Cree chief, Broken Arm, offering the Blackfeet gifts as a gesture of peace from the Iron Confederacy. In return for ceding certain areas as a "common hunting ground," the Blackfeet retained a large area as their exclusive territory. Stevens also promised that the Blackfeet would receive cattle, and be able to eat beef rather than the "poor bison meat," an offer that must have struck the Blackfeet as ludicrous, as it would a modern-day nutritionist.

As with Treaty 7 north of the Medicine Line, the Blackfeet believed that, in making a minor concession in the Three Forks region, they were protecting their homelands in perpetuity. Again the oral runs awkwardly into the written, and what was said was not what was given. By 1860 and 1862, gold was found, miners were trespassing and miner camps were being set up. In the "common hunting ground," the buffalo had been hunted to oblivion. In the Blackfeet territory, in the Sweet Grass Hills, through protection and husbandry, they would last a little longer.

By 1895, the Blackfeet were starving. The sacred areas encompassed by what is now Glacier National Park were sold to the United States government. Tourists would come. Historian Mary Scriver told me, "Everyone loved the stories and dancing and other exhibitions of Blackfeet culture, but they were not considered equals and they got to eat leftovers after the paying guests ate all the meat."[3]

Contrary to popular perception, the transition from bison hunting to agriculture was not something that the northern Plains tribes (Blackfoot, Plains Cree, Assiniboine, Saulteaux, Nakota and Dakota) resisted. Through generations of living on the Plains, they were hard-working and adaptive to new ways. The signing of Treaties 4, 6 and 7 in the 1870s, and the disappearance of the last of the northern bison herds, meant either changing or starving. During the treaty negotiations, Indigenous councils who were signatories were primarily concerned with having the tools and means to farm. In fact, the greatest impediment to farming would not be drought or flood or any other act of nature, but the colonial attitudes of federal administrators and the suffocating restrictions of the Indian Act.

In 1879, a system of Home Farms was set up on reserves under the control of Hayter Reed, who would go on to become Indian Commissioner of the Northwest Territories. Reed's antipathy towards Indigenous peoples resulted, in almost every possible way, in decisions that hindered Indigenous farming in a way no white settler would have tolerated, with every minute detail or purchase having to be approved by an Indian agent.

At a time when people on reserves were facing starvation, the Indian agent closely monitored every aspect of the control of cattle. Reed specified that individual cows were not to be slaughtered, even as people struggled to find ways to feed their families. The Indian agent also inventoried and controlled tools and seeds, and monitored rations. Farming instructors were brought in from the East by the Department of Indian Affairs, but they had no knowledge of the climate or soil of the Prairies, and their farming methods were unworkable in the region. At a time when many on reserves were unilingual (speaking their ancestral tongue), language was another major barrier. A more logical choice would have been to contract farming instructors among the Metis, who had been farming land along parts of the South Saskatchewan and Red Rivers for decades, but Reed and his department echoed the deep suspicion of the John A. Macdonald government towards the Metis.[4] In the eyes of Reed, the Metis were troublemakers and anything that would encourage further contact between treaty "Indians" and the Metis was to be discouraged, regardless of any knowledge they might bring as farmers.

Indigenous Plains people worked hard and adapted to an agricultural way of life, many becoming successful wheat and cattle farmers—so successful, in fact, that incoming white settlers complained that they were competing unfairly against them. In response to these complaints, the government initiated further measures to curtail Indigenous farmers from selling their crops or purchasing farm equipment. For decades, many farmers could not use any metal in their farm tools, and had to make wooden farm implements by hand.

That so many Indigenous Plains farmers persevered for so long, until aspects of the Indian Act were reformed in the post–World War II period, is a testament to their hard work and fortitude.

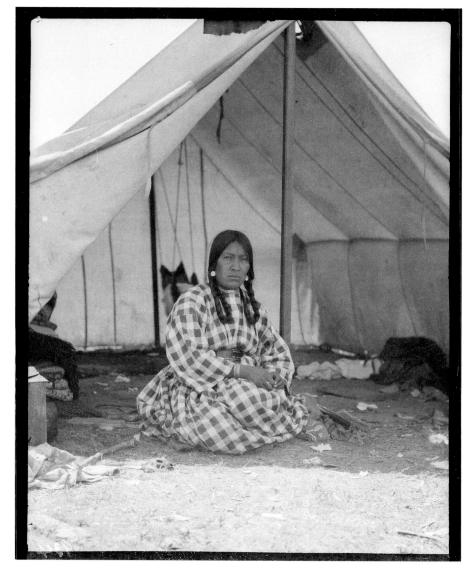

Good Spear Woman (Blackfeet), Montana, c. 1908. (**Walter McClintock**)

ON APRIL 3, 1932, THE DAUGHTER OF GOOD SPEAR WOMAN walked into the offices of the *Billings Gazette* with the written notes of her mother, who had passed just over a decade earlier.[5] The remarkable narrative brought back to life a horrific and tragic episode that many in Montana would rather have forgotten.

The late 1860s was a time of increased tensions in Blackfeet territory. While the Blackfeet had a long history of trade with white men, predating Lewis and Clark in the early 1800s, increased settler encroachment, the discovery of gold and the diminishing bison herds had upset any sense of equilibrium.

Malcolm Clarke, a successful white trader, lit the fuse. Clarke had married a Blackfeet woman but was known among the Blackfeet as a man with a temper. Many avoided him, but not so the Owl Child family, who were frequent visitors to Clarke's ranch. In 1867, horses belonging to Owl Child and Clarke were stolen, and Owl Child, believing Clarke was responsible, returned the favour by stealing a few of Clarke's horses as well as a brass telescope.

Accompanied by his teenaged son Horace, Clarke pursued Owl Child to his camp on the Teton River and there, in front of witnesses, beat him. There were also rumours that earlier in the year Clarke had raped Owl Child's wife. On the night of August 17, 1869, Owl Child and some Piikani warriors went to Clarke's ranch, ostensibly to give back some horses and settle matters. Things quickly went wrong, and while there are conflicting accounts of what exactly transpired, what is known is that at the end of it Malcolm Clarke was dead from an axe wound inflicted by Night Owl, and Horace Clarke was seriously wounded. The Clarke homestead was ransacked.

The press and white settlers called for retribution, and on the morning of January 23, 1870, a combined force of 347 soldiers and civilian volunteers attacked the winter camp of Chief Heavy Runner. The force was commanded by Colonel Eugene Baker, who was reportedly drunk that day. They had been ordered to find the camp of Mountain Chief, "hit it hard" and arrest the five Piikani warriors suspected in Clarke's death. Having been ordered by General Philip Sheridan to leave Chief Heavy Runner's camp alone, Baker assembled his force and marched under cover of darkness to avoid detection.

On this bitterly cold day in January, they charged the camp of Chief Heavy Runner, who had signed a paper of peace with US authorities. Despite being told by his scouts that this was the wrong camp, Baker ordered the attack.

"We were aroused by barking dogs," Good Spear Woman recalled. "Then someone came with word for my father, Heavy Runner, that the soldiers were coming. All was excitement and fright in the camp. But Heavy Runner told everyone to be quiet, that there was nothing to fear. He said he would show the whites his 'name paper,'"[6] documentation showing he had a peace agreement with the United States.

Chief Heavy Runner was shot dead and the mounted force raided the camp. Few men of fighting age were present, as most were off on a bison hunt in the Sweet Grass Hills. The soldiers went from tipi to tipi, shooting all inhabitants inside as well as those trying to run away.

"I rushed into another [tipi] where there were some sick and dying people," Good Spear Woman said. "I hid under a backrest on one of the beds. While there, I saw a knife cut a hole in the tipi and then a soldier thrust himself through the opening. He fired at every moving body. When he figured no one was alive, he left. I was small and quiet, so he didn't notice me."

When it was all over, 220 Blackfeet, mostly women, children and elderly, were dead and 140 were left alive. The camp and all its supplies, including nearly a ton of pemmican, were burned. The survivors were given some army tack and left to fend for themselves. When the warriors returned from the bison hunt to find only devastation, many dispersed east to Dakota country with survivors, or crossed the Medicine Line into Canada.

The press hailed Clarke and his force as heroes. Only later, as more facts emerged, did papers like the *New York Times* express outrage. No charges were ever laid and eventually the Marias Massacre (or Bear River, as the Blackfeet call it) faded from public memory. The site remains hallowed ground for the Blackfeet.

Victor Pepion (Blackfeet),
Browning, Montana, 1942. (**Henry Magee**)

ARTIST VICTOR PEPION (BLACKFEET) POSES IN OVERALLS outside the wrought iron fence at the Museum of the Plains Indian in Browning, Montana. Along with Gerald Tall Fathers and Albert Racine, Victor Pepion was one of three Blackfeet artists to study painting with the American artist Winold Reiss at his Glacier Park studio in Glacier National Park. The son of German immigrants, Reiss first attracted attention with his "New Negroes" of Harlem portraits, but as he travelled through Blackfeet and Blackfoot country in Montana and southern Alberta, his portraits of Indigenous peoples also received acclaim. Reiss believed

Top: Tom Spotted Eagle (Blackfeet)
and friends, Montana, c. 1912
(misidentified as Tom Magee in archives).
(Walter McClintock)

Bottom: A photo of Henry Magee,
c. 1910–45.

that photography could help break down the racial barriers of the time, and he also believed in the dignity of all peoples, following the credo of the German philosopher Johann Wolfgang von Goethe that there is "unity in all creation." As a young man, Pepion learned the techniques of painting from Reiss, but Pepion's own subject matter was decidedly shaped by his Blackfeet heritage.

In 1941, the Museum of the Plains Indian was built in Browning, Montana. Covering two city blocks, it was the first museum in North America dedicated to Northern Plains culture. With funding from the Indian Arts and Crafts Board, museum curator John Canfield Ewers[7] commissioned Pepion to create a series of murals for the entrance lobby of the new museum.

Pepion was an apt choice. He was the grandnephew of the famed Mountain Chief (Ninastoko), the last hereditary chief of the Blackfoot tribes and a great warrior and statesman. Mountain Chief became the inspiration for Pepion's work. He painted four large casein murals showing scenes of a bison hunt from the last century, and a buffalo robe that, in traditional Plains pictograph style, told the story of the many exploits and adventures of his grand-uncle as a younger man.

At the time, Mountain Chief was ninety-three years old, but he sat with Pepion and recounted his life as a warrior, which the artist then rendered in pictograph style. The images were numbered in sequence, such as 1. at the age of twenty-one, Mountain Chief slew several Anishinaabe who were hiding in a hole; 5. Mountain Chief successfully stole a fine sorrel horse from a Flathead camp; and 10. Mountain Chief and party, while moving camp, encountered a party of Sioux and scattered them.

Pepion did not hesitate to add his own contemporary touch to the bison robe. The figures and animals on display in the mural are brightly coloured, and the figures manifest more sense of motion than in traditional pictograph robes.

Pepion died tragically in a house fire in 1956 at the age of forty-seven. His legacy endures, not only in his artworks but also in the person of his grandnephew, John Isaiah Pepion, who is now a well-respected ledger artist.[8]

IN PURSUING ARCHIVAL RESEARCH, ONE OF THE CHALLENGES is that one may encounter instances where the name, place or time is incorrect; the notes of the photographer may be hard to read or mixed in with other notes, causing confusion; or perhaps an archivist, eager to fill in information, inadvertently attached the wrong data. This holds true for the photos of Blackfeet life in Montana from the early 1900s to the 1940s taken by Walter McClintock and Henry Magee (Thomas Magee's brother). Mary Scriver, local historian, author and former teacher on the Blackfeet reservation, helped me to unravel one of these "archival knots."

"I think that someone trying to be helpful saw 'Tom' on the photos of Tom Spotted Eagle and completed them as Tom Magee," Scriver told me.[9] "Or if one wanted to impute a malicious motive, one might suspect that they tried to make out Thomas as more 'Indian' than he was to make the photos more impressive." It was a common fashion then to dress "Indian" at times.

Postmaster and photographer Thomas Magee would have met photographer Walter McClintock many times during this period, as they were both photographing Blackfeet, albeit from different perspectives. But there is little or no resemblance in appearance or manner of dress between Tom Spotted Eagle and Thomas Magee.

"As postmaster of Browning and husband of a Piikunni woman, Thomas Magee knew the people so well that he was generally welcome anywhere with his camera. His resulting work is among the largest and most thorough, perhaps surpassed only by Walter McClintock. A major difference between the two is that Magee specialized in portraits of individuals and groups, while McClintock looked for rituals, ceremonies, and other activities," Scriver wrote. While McClintock's photographs are almost entirely of ceremonial aspects of Blackfeet life, and life in the camps, one finds little or no representation of how Blackfeet were actually living on the reservations in the early part of the century. Thomas Magee's photographs have some of the former but much more of the latter—Blackfeet people living and dressing as they "normally" would in the first part of the twentieth century.

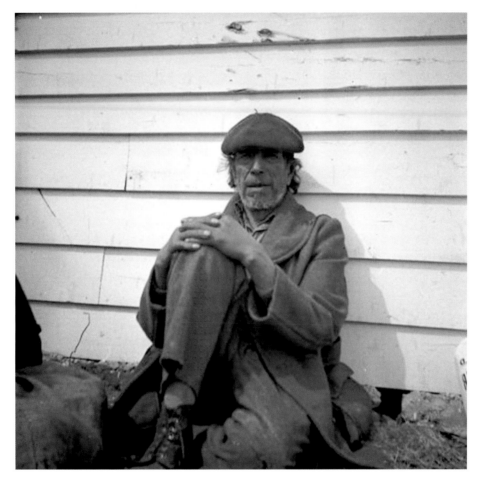

Tom Spotted Eagle (Blackfeet), Montana, c. 1930. (**Thomas Magee**)

"I expect that difference stems from the monetization of the photos," said Scriver. "McClintock was illustrating the [Blackfeet] tribe for books to sell to [a general], white readership; Magee was acting as a local photographer would today, recording families for their own use."

Thomas Magee produced a great variety of prints from his numerous photographs. Many of these were ordinary postcards with his name embossed on the front. Magee would sell these wherever he could, especially to tourists and tourist shops. He also made some large and beautiful sepia prints that he mounted on cabinet board. Magee published some of his photographs in magazines, and others were bought by large photo producers like the Keystone View Company, which published his work as stereopticon cards, two duplicate prints per card. McClintock would go on to publish many books on the Blackfeet, most notably *The Old North Trail: Life, Legends and Religion of the Blackfeet Indians* (1910). The readership for McClintock is clearly a white audience with a fascination for the "disappearing" Indian Plains life and exotic "period" photographs that fed into the Western romanticization of the period.

In the early years of the twentieth century, Blackfeet people still tried to adhere to wearing traditional clothes, and put up lodges with traditional exterior and interior designs during camps. This mode of behaviour, of course, appealed to McClintock's romantic sensibilities as a photographer. He wanted to capture this traditional way of life in the camps rather than any modern influences that the Blackfeet were successfully adopting on the reservations.

McClintock's first accomplice was William Jackson, a mixed-blood botanist who believed the "Indians" were disappearing and who was one of many whites at the time practising "salvation anthropology,"[10] rushing to record things before they vanished. McClintock was adopted by Mad Wolf, the Blackfeet chief, who named him White Weasel Moccasin. The "adoption" was formal enough to be registered in a letter at the Blackfeet Agency and no doubt flattered McClintock, though Blackfeet chiefs frequently used the practice of "adopting" whites as a strategic and diplomatic tool. For instance, Chewing Black Bone adopted Keith Seele, an Egyptologist of note.

"McClintock's adopted father, Mad Wolf, was a close friend and ceremonial partner to Chief White Calf, who adopted conservationist George Bird Grinnell,"[11] notes Adolf Hungry Wolf. Hungry Wolf's research questions the commonly held perception that McClintock "lived for years among the Blackfeet." McClintock first came to Blackfeet country in 1886, where he was adopted by Mad Wolf, whom he purportedly never saw again. McClintock returned for a sun dance in 1903 and then periodically in the summer, when the camps were taking place.

McClintock was by all accounts what we would today call a "loner." He had no wife or children. When he was not taking photos in Blackfeet country, he was often alone, writing. He did not hang out with any of his white contemporaries who were also taking photographs, such as Thomas Magee or James Schultz. Louis (Plenty Treaty) Bear Child, whom McClintock sometimes hired as his guide and interpreter, found him a "quiet and decent fellow" but aloof.[12]

While there is aesthetic beauty in McClintock's Blackfeet photos, and often a sense of intimacy, especially amongst the women and children, it is a narrow lens, a focus on only one aspect of Blackfeet life at the turn of the century. McClintock's gaze was directed to the past, to an ideal he sought of a way of life lost, and in that limited focus he failed to capture the resilience and adaptability of the Blackfeet people.

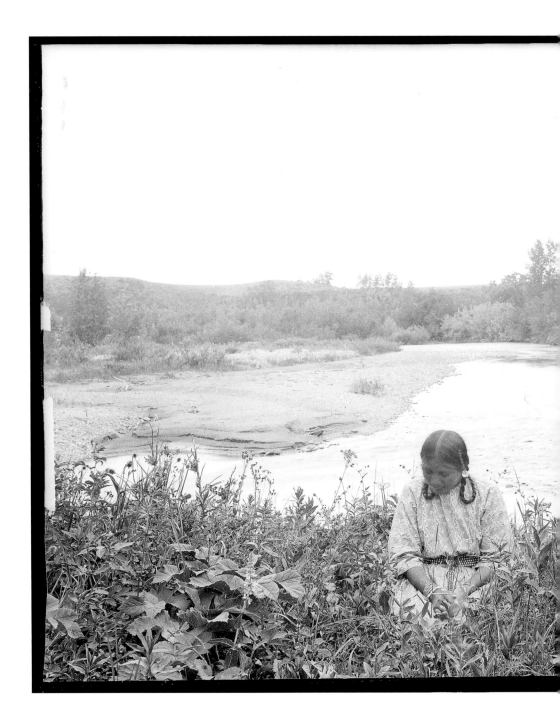

"A hot ride over prairies . . . down the Cut Bank cool. Riding up to lodge, saw a few feet away and on river bank a young Indian woman gathering strawberries. Picturesque. Long hair in braids over shoulders . . . Picketed horse on hill, then asked for [a] picture. Refused. Told her she ought to have it for her lover to show him how fine she looks. That seemed to decide the question so she came, kneeling in the grass as directed. That was Strikes in [the] Night."

—WALTER McCLINTOCK,
from his notes on the day this photograph was taken. [3]

Strikes in the Night (Blackfeet), gathering strawberries, Cut Bank, Montana, 1906. (Walter McClintock)

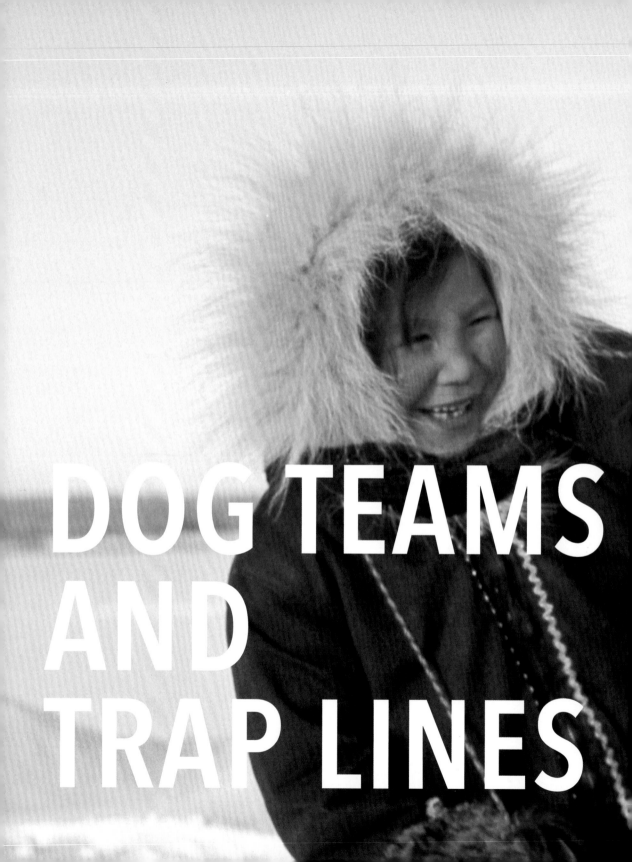

DOG TEAMS AND TRAP LINES

NORTHWEST TERRITORIES AND YUKON

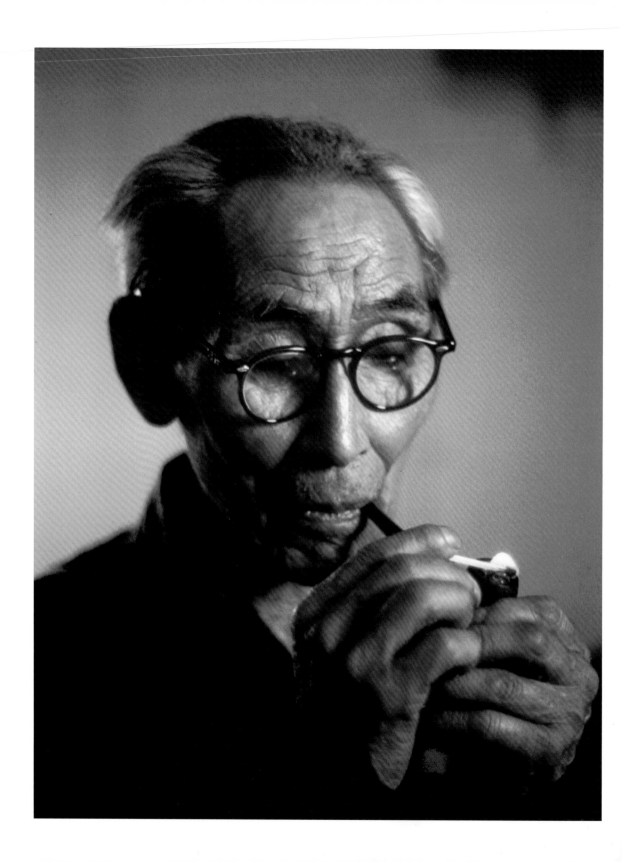

NORTHWEST TERRITORIES

Stories have shaped the landscape and the people of the Northwest Territories. Among the Dehcho Dene there are the legends of Yamoria, which vary from region to region.

One of the most well-known tells how the hero fought giant beavers that wrought fear among all in the Great Bear Lake region. Long ago, he chased the giant animals down the lake to the Den Cho (Mackenzie River), where he slayed them and pinned their pelts on top of Bear Rock, overlooking the village of Tulita. Yamoria cooked the beaver meat, which started fires that raged in the surrounding hills for days, the site today of natural gas deposits. Dene elder George Blondin (1923–2008) has described the three dark circles found on Bear Rock as essential to the survival of the Dene as a people.[1] Today, those symbols are integrated on the Dene Nation logo.

When Blondin was born in the Great Bear Lake area of the Northwest Territories in the early 1920s, people placed their currency in what was known as "medicine power," rather than in money, as an indicator of one's success in life. Success meant supporting family and community by being a good hunter-trapper, by sharing knowledge of how to survive in often harsh conditions and, importantly, by sharing what one had.

"My father wrote about these things because they are important to being Dene," remembered his son, Ted Blondin. "Medicine power is a phenomenon that is hard to understand and so it is not spoken of openly. But my father meant only to preserve this knowledge and he worked hard to explain it. He knew young people weren't sitting around the fire listening and talking to the old people so much anymore, and so he wrote down stories so they could read them."[2]

The Northwest Territories encompasses 1.346 million square kilometres, comprising the regions of Dehcho, North Slave, Sahtu, South Slave and Inuvik. It is home to 44,000 people, with half of the population Indigenous. Around 9 percent are Metis, mostly on the south side of Great Slave Lake. In the city of Yellowknife, 11 percent are Inuvialuit, and in the Far North the Dene make up roughly 30 percent of the territorial population. While modern living has brought huge changes in technology and communication, there are still many who return to the land to hunt, fish, trap and connect with nature.

Much of the history of the Northwest Territories, through an Indigenous lens, has been about the land: protecting the ecosystem, responding to southern projects like the Mackenzie Valley pipeline proposal in the 1970s, and fighting for recognition of sovereignty over Denedeh, Land of the People.

On October 3, 1969, the Indian Brotherhood (IB) of the Northwest Territories was established among sixteen chiefs. The Indian Brotherhood was a precursor to the Dene Nation established in 1976. The first president of the IB was Morris Lafferty of Fort Simpson, with Mona Jacobs succeeding him. The mandate of the Brotherhood was to ensure the protection of existing treaty rights of the Dene. Treaty 11, the last of the numbered treaties in Canada, had been signed in 1921.

A major issue for the Brotherhood was the plan to carry natural gas via a pipeline through the Mackenzie Valley to southern markets in Canada and the United States. The environmental impact of the pipeline was a significant concern, as was the urgent need to define treaty rights in the context of large resource extraction projects. Department of Indian and Northern Affairs minister Jean Chrétien appointed Justice Thomas Berger from the BC Supreme Court to lead what would become known as the Mackenzie Valley Pipeline Inquiry. Berger's approach to the inquiry was groundbreaking, granting environmental and Indigenous organizations funds to prepare their own cases and put them before the committee that gathered in Yellowknife, NWT. In addition, roving hearings were held in thirty Dene, Inuvialuit, Metis and non-Indigenous communities across the territory.

The inquiry's final report was released on May 9, 1977, and became a surprise bestseller, with ten thousand copies in circulation by the end of the first week. As a result of the work of the Berger Inquiry, the proposed Mackenzie Valley pipeline project was, at least temporarily, placed on hold. Importantly, the process would foreshadow many future Indigenous and environmental responses to pipeline and other projects with an impact on the land.

Today, the Northwest Territories is officially a multilingual territory with eleven official languages: Chipewyan, Cree, Tlicho, Gwich'in, North Slavey, South Slavey, Inuktitut, Inuvialuktun, Inuinnaqtun, English and French. In *Denendeh: A Dene Celebration*, René Fumoleau wrote, "The climate dictates that our people must be wily and strong, innovative and resourceful."[3] Those characteristics are likely to be increasingly important as the region faces many challenges, from climate change to balancing economic development with the need to preserve the land, the animals and the way of the people.

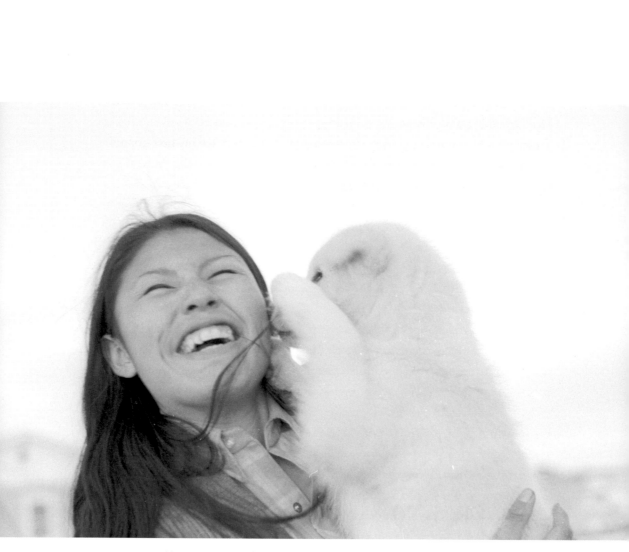

Mary Jane Martin (Yellowknives Dene), Dettah, NWT, 1971. (René Fumoleau)

AS AN OBLATE PRIEST, RENÉ FUMOLEAU lived on the land with Dene families for decades, and began compiling photographs around 1964. He remembers getting his first camera, and mailing his initial photographs to his mother in far-off France. He wanted to show her what life was like in Dene country of the Northwest Territories and give her some concept of the people and of the land, so different from his country of birth. His mother wrote back to "tell me how good the photographs were," and from there photography became a passion.

Fumoleau's first camera was a 35-millimetre Pentax without a built-in light meter, and cost him one hundred dollars. With that camera, and another Pentax he later purchased, this time with a light meter, he took over fourteen thousand photographs, which now reside with the Archives of the Northwest Territories. The thousands of photographs became a lasting record, not only of a rapidly changing way of life, but also of the strength and resilience of Denedeh.

"Soon I had my camera [with me] every place that I travelled and was taking pictures constantly of life back then," he recalled. Fumoleau is grateful to the Dene people in the communities he visited for welcoming him, and also for showing him Dene life and how to achieve a balanced relationship with the land, animals and water. "These people were very patient with me," he said. "I learned so much. I owe them a lot."

Over the decades, his photographs achieved an admirable intimacy. Fumoleau took photos of day-to-day life, in the bush and in the towns, and across generations—from elders to infants. He was in Yellowknife during the early days of the Indian Brotherhood and rubbed shoulders with the emerging political leadership of the group, people such as George Blondin, Georges Erasmus, Cindy Gilday and Steve Kafkwi. He attended gatherings and assemblies and took many photographs of this critical time in Dene politics and rights. But it is his photographs of children at play, elders in repose in their homes, men hunting and families camping that have a special resonance.

Fumoleau credits the Dene families who embraced him back in the 1950s with giving him the eye and the patience to capture moments in film. In 1975 he wrote his first book, *As Long As This Land Shall Last*, a political history of the Dene in the Northwest Territories, inspired by not only his photographs but the

research he had undertaken, including interviews with elders and visits to archives, as well as the oral narratives that he wrote down in each community and camp he visited.

Fumoleau travelled in all seasons, often by boat along the rivers in the summer, and in the winter by dog team. He was very proud of his team, and to this day jokes that he "had the fastest dog team in the territory."

Fumoleau laid down his camera in 1994, but he still carries the experience he gained. "There is beauty in the Dene language," he said. "There is beauty in all the seasons and there is beauty in the young and the old. There is beauty in the land, sky, animals and trees."

THE DENE HAMLET OF JEAN MARIE RIVER is located about five hundred kilometres west of Yellowknife. In the days before treaty, the Dene, like other Indigenous nations, had only one name. The federal government, with the aid of missionaries, began arbitrarily assigning surnames to people in the region. In the Jean Marie River region, most families were descended from three sisters, Marguerite, Sophie and Cecile. In many cases, first names or nicknames became the new surname.

Marguerite married Baptiste Norwegian,[4] and their son Louie Norwegian became a respected leader in Jean Marie River and guided the development of the community for many years. He was a key player in what would be a unique chapter in the history of Canada's residential and day schools.[5] When government officials came to the community to take the children away to school in Fort Providence, the adults of Jean Marie River said no. Louie Norwegian was a big reason behind this refusal. He was haunted by the cries of women he'd hear at night, who were missing their children hundreds of kilometres away, and also by the suicide of his young son who had attended the residential school. Norwegian and other prominent community members lobbied the local MP for their own school and finally managed to convince him of their need. Permission was granted, but there was still no funding available for the building.

Louie Norwegian (Dene), age forty-five,
Jean Marie River, NWT, 1945. (**June Helm**)

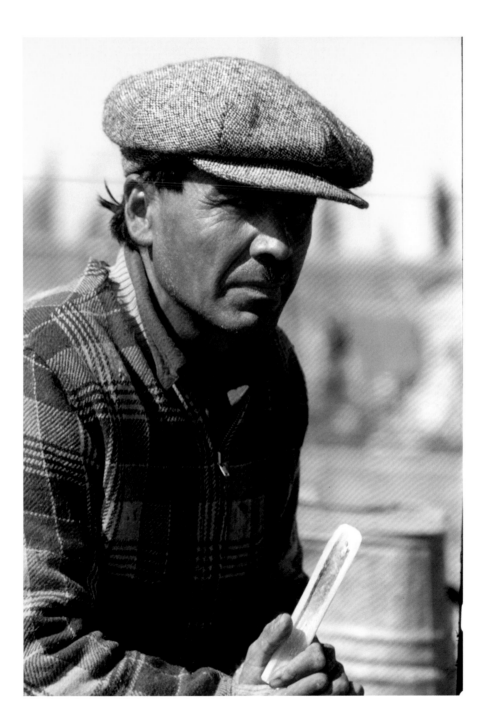

Antoine Mountain (Dene), sketching, Sans Sault Rapids, NWT, 1980. (**René Fumoleau**)

In time, the hamlet was able to raise enough money selling fish and lumber to fund the construction of the schoolhouse. The next challenge was to find a teacher, an especially difficult task since there was no money to pay for one. Teresa Carterette, an anthropologist who was studying the Dene of Jean Marie River, along with anthropologist and photographer June Helm,[6] volunteered to teach in the school's first year. In exchange, Norwegian promised Carterette all the firewood and food she would need.

Norwegian arranged for a bargeload of logs to be shipped along the Mackenzie from Peace River, Alberta. Men from the hamlet chipped in and put up the new schoolhouse. The barter arrangement with Carterette allowed the school to open, and by the fall of 1951, Carterette was teaching outdoors on the banks of the Mackenzie when weather allowed, and inside the classroom when it didn't. Although she only taught for the first year, her volunteering gave the people of Jean Marie River the chance to establish themselves for the following years. More than one hundred students eventually received their first education in the school, attending up to grade six. Later, the federal government began offering support, and in 1980 a new school was built in Jean Marie River. It was named the Louie Norwegian School.

"WE WERE SPRING HUNTING AT MOUNTAIN RIVER, which is at the Sans Sault Rapids [south of Fort Good Hope, Northwest Territories], when René Fumoleau and some filmmakers showed up," artist Antoine Mountain recalled. Mountain River is an ancient travelling route to the Yukon, while other routes like the Rampart River are more spring hunting areas for the Dene, with lots of muskrat, beaver and ducks. Mountain was at camp with about twenty others, having recently returned from Toronto, where he attended art school. At the time, only around five percent of Dene students were graduating from high school, and Mountain was able to secure funding from the Dene Office in Yellowknife to study art in Toronto.

"My generation of Dene were all born right on the land and not in town or any hospitals," Mountain said. "I was born about ninety miles north of Fort Good Hope in the winter of 1949. My mother was the late Mary Mountain [Barnaby]. When we asked her about [my birth], she said they stopped for only one day when she gave birth to me and the next day they were travelling by dog team again."

Antoine Mountain believes the Mountain River is named after his grandfather, Peter Mountain Senior, who used to travel frequently between the Yukon and the Northwest Territories by various rivers, including the now-named Mountain River.

Antoine Mountain was fortunate in his early youth that he was able to avoid being sent to residential school for a number of years, and so spent a good portion of his childhood living off the land. He looks back fondly on his childhood, reflecting on traditional life in the mountains, when river travel was still done by mooseskin canoes. As a young child he had a passionate interest in drawing, but there were no pencils or paper to realize his dreams, so he improvised. "I did all my drawings right on blocks of wood, using charcoal from the fire, and then I'd always be a little sad to see my artwork go up in flames," he recalled with a laugh. "Every stick of wood was very important, living on the land, so my early art fed the flames."

Working for the then Indian Brotherhood of the Northwest Territories, Mountain first met René Fumoleau in the early 1970s and was assigned to assist Fumoleau on a book he was writing, which eventually became *As Long As This Land Shall Last*. The collaboration involved much travel across the territory and lots of research. This was all pre-computer, of course, so a lot of Mountain's work was typing up the countless notes that Fumoleau wrote from his interviews with elders and compiling the photos Fumoleau had taken.

"I appreciated how much work he put into trying to get all the details together about information that goes all the way back to the signing of Treaty 8, in the year 1899–1900," Mountain explained. "It had to take a person who had a lot of patience and who was very meticulous with details, and Fumoleau is that kind of man."

PAUL WRIGHT (1921–99), SHOWN HERE WITH PUPPIES, was a well-respected and admired leader among the Sahtu Dene and across the Northwest Territories. Born in the Mackenzie Mountains, he was raised on the land and carried that connection throughout his life. During World War II, he was one of the guides for the American soldiers building the Canoe Pipeline. Along with his wife, Mary Rose, he moved to Drum Lake in 1974 and there built a cabin in the woods. They lived there every summer, and it soon became a place where they would take a younger generation of Dene to experience living off the land as well as the teachings of

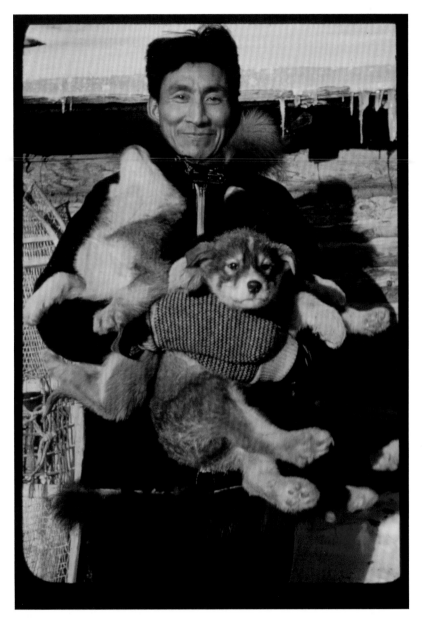

Paul Wright (Sahtu Dene) with a handful of puppies, NWT, c. 1955. (**Bern Will Brown**)

Dene culture. Both he and his wife attended many gatherings and assemblies of the Dene Nation, and they became respected, not only for their knowledge and guidance, but also for their calming presence when contentious issues were being discussed. As former commissioner Dam Marion recalled, "He could put calm and peace in a meeting, when meetings got excited. Paul would come in and always remind them that all of them were at the table for one purpose, and he would come across so strong, that all the other leaders would reflect that and they would tone down."

Despite the tremendous changes under way in the Northwest Territories in the 1970s and '80s, Wright always reminded people of the older times when people lived off the land. When things were tough or challenging, Wright said, you learned to come together to work them out; you couldn't do it on your own. The perspective he gave, along with other Dene elders of his generation, provided a stabilizing anchor during the years of negotiations with the federal government.

Throughout his life, Wright was also a strong advocate of the Dene language. He believed that keeping the language alive and healthy was essential for the well-being of succeeding generations. "If you are Dene and you speak it, you need to use it to speak for the people," he wrote.[7] "The language is what Dene are born with, all Dene out there have to follow it."

Over the years, Wright also wrote down the Dene laws of living in syllabics. In them he explained, "Children are raised alone, they are raised well out on the land. If they look after themselves well, they might have a vision, start to have dreams and will be able to process traditional medicine. They look after themselves well, a child [who] looks after her/himself like that will have a vision for different things if s/he dreams about it. A person that is able to know it will know, he will feel it. If a child is like that and has traditional medicine power, s/he will have dreams. If it was like that s/he will have a vision and will work well on his/her own."

Julie-Ann Andre (Gwich'in) cutting fish,
Tr'ineht'ieet'iee, NWT, 1978. (James Jerome)

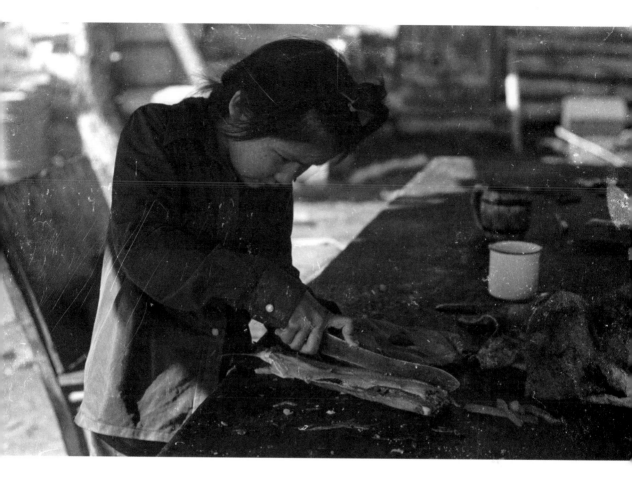

JAMES JEROME WAS BORN ON JULY 31, 1949, in the northern hamlet of Aklavik, Northwest Territories. He grew up, as generations of Gwich'in children had, in a camp on the land known as Big Rock by the Mackenzie River. His father, Joe Bernard, was Chief of the Gwichya Gwich'in of Arctic Red River (Tsiigehtchic), as well as a Special Constable RCMP and a trapper. His mother was Celina (née Coyen) Jerome. The youngest of four brothers and two half-sisters, Jerome was able to spend years with his family, hunting and fishing, before attending Grollier Hall Residential School in Inuvik, Northwest Territories. At the age of twelve his mother gave him his first camera, a gift that would inspire a career and leave a legacy.

Both of Jerome's parents died before he completed high school. After graduation, Jerome travelled Canada and trained as a welder, before returning to his ancestral home in the Mackenzie Delta. There, his artistic inclinations were rekindled. As he spent time on the Delta, his attachment to Gwich'in culture and traditions strengthened, as did his desire to record traditional ways that were gradually disappearing under the pressure of southern culture and technology.

In 1977, Jerome worked for the now defunct *Native Press* newspaper as a staff photographer for eight months. While there, he met professional photographer Tessa Macintosh, who'd recently arrived in Yellowknife to help train First Nations photographers.

Macintosh recalls their meeting: "Shortly after 1977, I met James. He'd applied for a job to study photography and learn on the job. It was a position for reporters who weren't really trained in photography but enjoyed it.

"We started working together and sometimes we did the same job together. He had projects he found interesting and he had connections, so he'd go off and do them. Stuff that was out there on the land and on bush with First Nations friends and the connections he had all over."

From 1977 to 1979 Jerome took thousands of photographs in the Fort McPherson and Peel River regions, documenting life in the summer and winter camps as well as trapping and fishing activities along the river, and large events such as the Arctic Games and other social events. He also produced an impressive portfolio of portraits, self-portraits, and photos of contemporary life in the towns. Jerome used the darkrooms at the Science Institute in Inuvik as well as the *Native Press* offices in Yellowknife to develop his photographs.

As Macintosh points out, this was before the days when signed permission slips were required to take someone's photograph, and there was very much an element of trust involved. "I think [James] certainly had a passion and an eye, and he had a rapport with the people of the North," she says. "I went back and reviewed the contact sheets of that time in the bush . . . and you can see he worked in sync with people. There was a rhythm involved and he never bothered people. It was just understood in the old bush way. Trust is there because you live together. James would have been in the tent next door. Eating together and hunting.

Knowing James, he would have put down his camera and gone hunting as well. He was a real bushman."

The life and the career of this groundbreaking Indigenous artist was tragically cut short by a house fire in Inuvik on November 17, 1979. At the time of his death, Jerome was finishing a book about Dene elders of the Mackenzie Valley titled *Portraits and History of the Dene Elders*. This was lost in the fire that claimed his life, as were many of his photos, although thousands of negatives were salvaged by his wife, Elizabeth. Jerome's remaining portfolio, a collection of more than 9,000 negatives, are now housed with the Northwest Territories Archives, thanks to a donation by his son Thomas. They give an invaluable picture of Gwich'in and Dene life during the short time Jerome had to devote to his passion.

Senior archivist Erin Suliak of the NWT Archives has related how many of the negatives were seriously damaged, although the NWT Archives was able to do vital conservation work to preserve and restore what they could. Then, in 2008 and 2009, the archives received federal funding and were able to partner with the Gwich'in Social and Cultural Institute (GSCI) on a project to revisit the places where Jerome had taken his photographs.

"The success of the project was due entirely to this partnership," says Suliak. "We were able to do identification workshops up in the Mackenzie Delta, in a region that the GSCI had already done field work on. We went up with some key images and sat down with elders and we went through a couple hundred key images to determine 'Who is this?', 'Where is this, exactly?' and 'What's going on here?'

"It was just incredible. We got the information from the elders. We also worked with the GSCI to get the current traditional names for all of the camps and places. To me, this was such an important part of this project. It's not very often that we're really able to dig deep and get the correct names for people and the correct names for places."

Through this work, more than 3,500 of James Jerome's photos were catalogued and digitized by the NWT Archives, ensuring Jerome's legacy will last for generations.

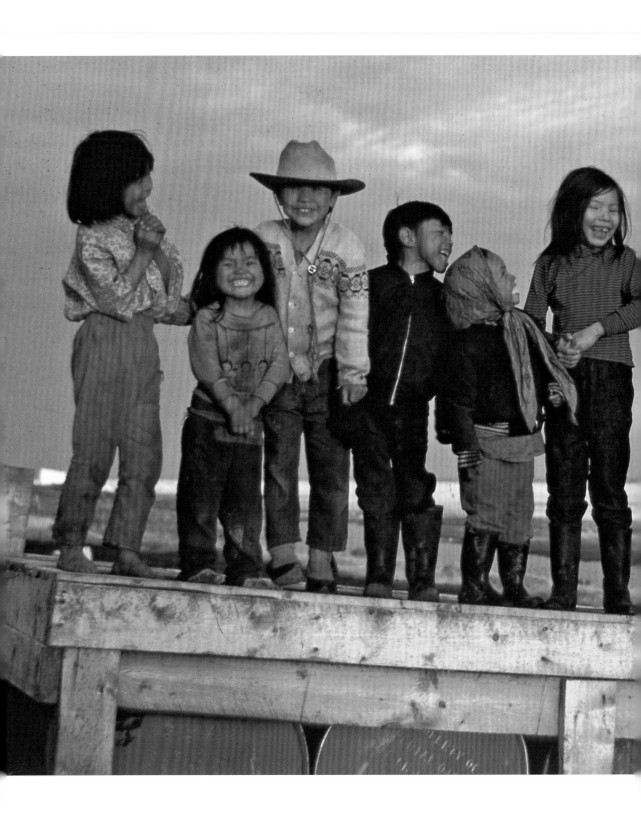

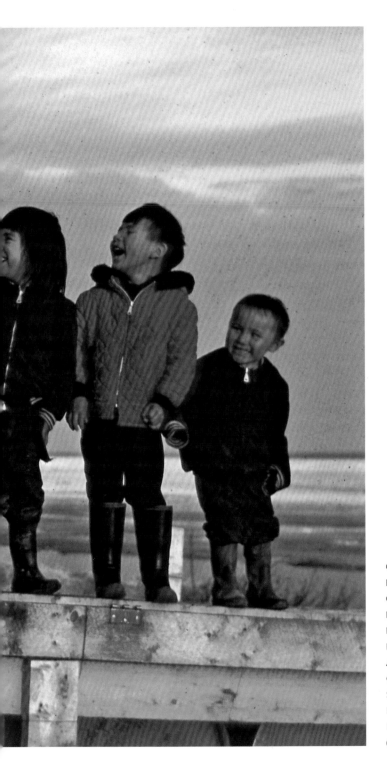

Children (left to right):
Bernice Taneton,
Goldie Modeste,
Patricia Takazo,
Paul Kodakin,
Lucy Ann Kenny,
Anne Marie Bezha,
Carolina Kenny,
Steven Taneton and
Leonard Kenny (Dene),
Deline, NWT, c. 1968.
(René Fumoleau)

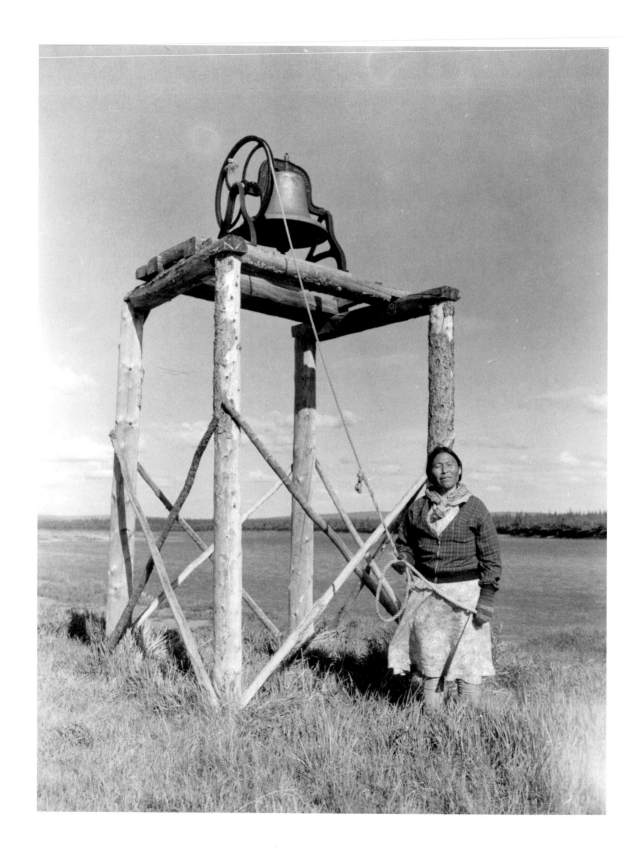

YUKON TERRITORY

On Bonanza Creek in the Klondike on August 17, 1896, the prospecting party of Dawson Charlie and his brother, Patsy Henderson (Koolseen), Skookum Jim, and Kate and George Carmack discovered gold.

Their find would precipitate the Klondike gold rush. Almost overnight, Dawson City was born. As news spread, thousands—including writers such as Jack London and Robert W. Service—would make the trek to the Yukon in the hope, usually in vain, of finding riches. The gold rush would forever change the world of the Kutchin, Hän, Kaska, Tagish, Tutchone and Tlingit nations.

Dawson Charlie was born around 1860 in Tagish, Yukon. His Tlingit name was Káa Goox and he was born into the Dakl'aweidí (Wolf) clan. Skookum Jim, a.k.a. James Mason (1856–1916), was a Tagish man of the Dak l'a Weidi Clan. Patsy Henderson, a nephew of Skookum Jim, was the only original member of the discovery party to later tape the story of the find, even though he was back at the camp at the time of discovery.

As Henderson recounted:

> *Three weeks we worked there and three weeks time we take out gold not on the bedrock on the side, the Creek, side of the Creek, we turn on the water all day, we work on our own on the rock. Three weeks time we take out gold $1,440.00 gold, three weeks time, but the half gold we loose him, the box too short, we hurry, that time, September, Klondike cold, she snow, very cold. "We got to quit," George says, "I guess we got enough for grub stake, $1,440.00 we got enough for grub stake."[1]*

Dawson Charlie staked a claim and also became the first known member of a Yukon First Nation to be exempted from the provisions of the Canadian Indian Act for making his claim. As a British subject, Dawson Charlie could now vote, sue or be sued, be called for jury duty, and legally buy and consume alcoholic beverages[2] in a process of "enfranchisement" similar to that which thousands of Status Indians would experience over the coming decades—in reality, being stripped of all treaty rights.

Skookum Jim remained highly regarded by Indigenous people of the region. In his will, he arranged for the fortune he had acquired in the Klondike gold rush to be put in trust, and the interest from the trust to better the health and education

of "Indian people in the Yukon." The interest from that fund continues to assist Indigenous people in the territory to this day.

While the gold rush was short-lived (within a decade the original stampede of twenty-five thousand had dwindled to a few thousand), its impact on Indigenous peoples was huge. The areas directly impacted by the gold rush were relatively small in the vastness of the Yukon, yet whole communities of Indigenous peoples were shunted aside and marginalized. There was zero respect for any "Indian" claims to the land or trapping territory; few "Indians" were welcome at the claim sites, other than as guides or pack labourers. But it was introduced diseases that had the most brutal impact, reducing the Indigenous population by thousands.

IN 1951, ANTHROPOLOGIST CATHARINE MCCLELLAN, along with colleagues Julie Cruickshank and George Leechman, was in Teslin, Yukon, taking photographs and recording oral Tlingit and Tagish stories. There, over the course of two days, on March 13 and 14, Jake Jackson of the Deisheetaan clan in Teslin visited McClellan. Jackson was well respected in the region, had worked as a sailor, miner, carpenter, hunter and trapper, and was a powerful and knowledgeable storyteller. Jackson told McClellan the story of the great flood, as he wanted to convey to what he called the "big bosses" in the South how long the Tlingit and Tagish people had been on this land.

As McClellan told the story:

> *Jake came to my cabin in the evening, tired from cutting wood all day. He evidently had two reasons for his visit. First, he wished to retrieve his spit can—a tin can lined with paper into which he spat the juice from the snoose that he chewed. Some non-Indians are sensitive to having these cans about, so Jake first apologized, "I made a big mistake last night." I assured him that he was welcome to leave his can in my cabin any time he wished and also presented him with a can of Big Ben chewing plugs. Second, we had spoken the previous night about the Indian land claims problem. Now he wanted to explain clearly how long his ancestors had*

*been in the vicinity of Teslin by telling the Flood Story. Before beginning,
however, he checked again to find out for whom I was writing the sto-
ries, for he wanted to be sure that the "big boss" and other "big shots"
would see it. Indeed he suggested that it would be far better if the big
boss could come and hear for himself.[3]*

With the Klondike gold rush at its apex in 1900, Chief Jim Boss (Kishxóot) of the
Ta'an Kwäch'äan lobbied the commissioner of the Yukon, William Ogilvie, for a
reserve at Lake Laberge (Ta'an Män). Boss had personally surveyed the land, and
asked that 1,600 acres be set aside for his people. Ogilvie granted only 302 acres.
Undaunted, in 1902, Boss petitioned the Department of Indian Affairs in Ottawa
for more land. He decried the land stolen by prospectors and the harmful impact
of the gold rush on local wildlife that the Ta'an Kwäch'äan had depended on.
While the response he got was simply a vague promise that the North-West
Mounted Police would do something to protect his people and the game, Boss's
letters constituted the first land claims negotiation by a First Nation from the
Yukon Territory—a process that would continue into the twenty-first century.

ANGELA SIDNEY WAS BORN NEAR CARCROSS, YUKON, in 1902. Her mother, Maria
John, was Tlingit, while her father, John, was Tagish. Her father's cousin Skookum
Jim is one of the people credited with discovering gold in the Klondike, which
precipitated the gold rush. Angela would later recall, in one of her many stories,
how Skookum Jim rescued a frog that he had found trapped in a ditch. The frog, in
turn, healed Jim when he got injured. Later, she recounted, the frog appeared to Jim
in the guise of a beautiful woman and told him he'd find luck if he ventured to a

Portrait of Angela Sidney (Tagish),
Carcross, Yukon, 1951. (**Catharine McClellan**)

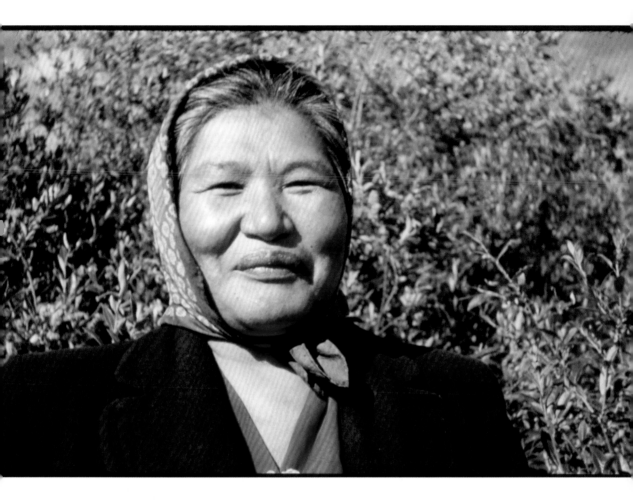

"I have no money to leave for my grandchildren. My stories are my wealth."

—ANGELA SIDNEY

spot down the Yukon River. Skookum Jim followed the dream and discovered gold.[4]

The Tagish people had traded with the neighbouring Tlingit in the Carcross area for centuries, and as is often the case with long-standing trading relationships, there was much intermarriage. By the middle of the nineteenth century, the Tagish were speaking the Tlingit language more often than Tagish, and Tlingit customs were being adopted as well. With Skookum Jim's discovery of gold, and the ensuing gold rush, the Tagish language and customs were further eroded.

From childhood, Angela Sidney was immersed in the Tlingit and Tagish oral narratives told to her by parents and relatives. These myths and legends left an indelible impression on her, and as she grew older Sidney recognized the importance of these stories and passed them on through storytelling and eventually wrote them down on paper.

Angela Sidney spoke only Tagish until the age of five and would go on to be one of the last fluent Tagish speakers, still speaking the language eighty years later. She was witness to the many changes happening in the community and also the erosion of not just language but rituals. Angela was fascinated with the stories of how things were done in the past, but also worried about the impact of the modern world on traditional ways of life. Angela noted that she had never received a potlatch name because, when it was time for her to be named, there was no elder in her clan who knew the protocols of naming. Angela also commented on how her puberty seclusion, a long-standing tradition among Tagish girls, was not taken as seriously as it had been in previous generations, and that hers was even interrupted so she could return early to look after her ailing mother.[5]

In the 1970s, Angela worked with anthropologist Julie Cruickshank to record the Tagish stories she had inherited and preserve them for posterity. These included creation stories of how Crow made the world, how the animals came to be and how the seasons were formed. The stories spoke of the old days when the four-leggeds could transform into human guise and also of the lost times when animals and humans spoke a shared tongue. There were also "lesson" stories of how one should behave and protocols of respect, as well as adventure and humorous tales.

In 1988, fellow storytellers Louise Profiet-LeBlanc and Anne Taylor founded the Yukon International Storytelling Festival in Whitehorse. The prestigious festi-

val, honouring storytelling from around the world, was inspired by Sidney's life work. That same year, Sidney became the first Indigenous woman from the Yukon to receive the Order of Canada.

GEORGE JOHNSTON (c. 1884–1972), whose Tlingit name was Kaash KlaŌ, was a notable fixture around Teslin for decades. He was an entrepreneur, hunter, trapper, store owner and photographer. With a Brownie box camera he purchased, Johnston taught himself how to take photographs as well as how to set up, from scratch, a darkroom in the corner of his bush cabin. From there, he developed hundreds of photographs depicting Tlingit life, both in the village of Teslin and in the country, from the 1920s to the 1950s.

In the summer of 1928, Johnston purchased a new Chevy with funds he'd raised from trapping. Getting the car to Teslin was not an easy feat, however, as there were no suitable roads. Johnston had to transport the Chevy several hundred kilometres upstream along the Yukon River, and then he, with the help of friends, constructed over five kilometres of road to accommodate his car. Johnston's road would eventually be incorporated into the Alaska Highway. Painted white in the winter and black in the summer to enhance its use for hunting, Johnston's Chevy achieved an iconic, even legendary status, not only in Teslin but in the territory as a whole. He started up what was likely the first Indigenous-run taxi service in North America, and in the winter he fitted the tires with chains so he could drive people up to ninety kilometres over the frozen waterways.

Johnston's Brownie was a constant companion during this period. He took intimate pictures of local people tanning hides, hunting and fishing, playing sports, travelling by dog team and snowshoe, and attending church, as well as those using his taxi service. Johnston also operated a general store in the community, which sold everything from hunting supplies to candy. "I remember buying pink popcorn from him for a nickel," Jake Jackson's granddaughter Mary Blahitka said. "What a kind man he was."

Overleaf: Girls baseball team (Tlingit),
Nisutlin River, Yukon, 1941. (**George Johnston**)

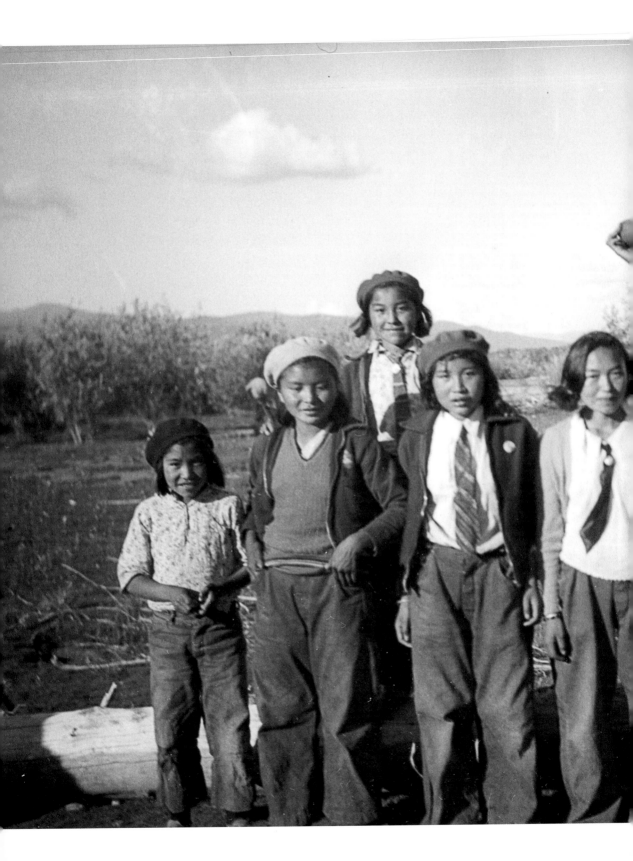

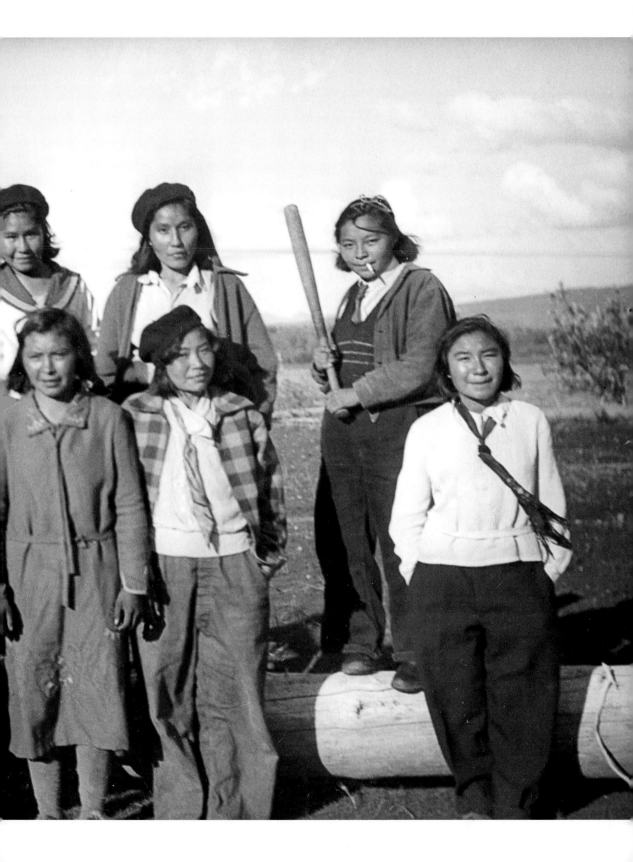

"My grandfather was a beautiful man, gentle and kind," Shan Tla Dewhurst, his granddaughter, recalled. When people needed a hand, Johnston could be relied upon. He was also good at communicating and negotiating with Southerners at a time when most Tlingit did not speak more than a few words of English.

Along with Inuit photographer Peter Pitseolak, George Johnston can be considered a pioneer of Indigenous photography, predating the upcoming generation of Indigenous photographers by many years. In fact, he acquired his Brownie a full two decades before Pitseolak, who began taking pictures in the 1940s. The hundreds of his photographs that survive run contrary to any narrative of depression or poverty. People may not have had much money, but they were hard-working and enterprising. The land provided food, shelter and clothing, and Johnston's photographs capture the expertise of Tlingit men and women who were highly educated in living off the land. Beyond mere survival, however, Johnston's lens captured a spirit of fun and play, of community coming together and also adapting to and accepting changes.

JAKE JACKSON WAS RAISED BY JOE AND MARY SQUAM OF TESLIN, Yukon. His granddaughter, Mary Blahitka, believes he must have gone to day school somewhere around Juneau, Alaska, possibly at the Sitka Industrial Training School.

By the age of fourteen, Jackson was working aboard steamships that carried freight and passengers between Juneau and Vancouver, BC. He worked on the steamships until he was around twenty, then returned home to Teslin. "He was very knowledgeable about sailing," Blahitka recalled. "In fact, when Teslin Lake was very, very rough, Mom [Pansy Jackson] said he used to set up a sail in his boat and he could sail all the way from Brooks Brook to Teslin in a matter of an hour. He knew how to set a sail and he would also secure a log on the side to stabilize the canoe in rough waters—much like an outrigger."

Jake Jackson with daughter Pansy (Tlingit), Teslin, Yukon, c. 1948. (**Douglas Leechman**)

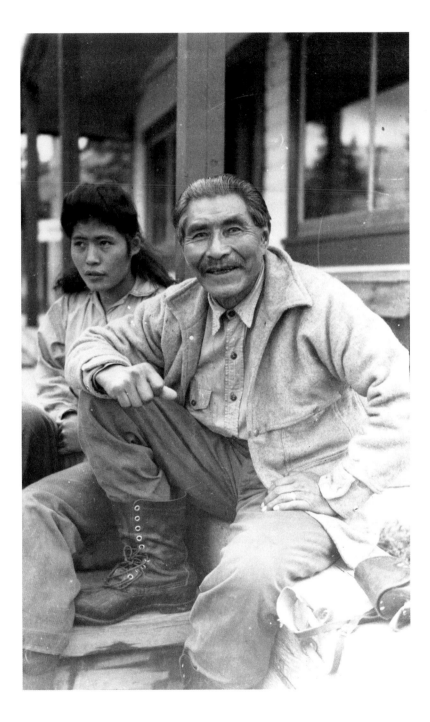

He and his wife, Mary Sydney Jackson, led a semi-nomadic life. They maintained a house in Teslin they called the Seghedi Hit (Beaver House), where they would stay for part of the winter. But they also had a cabin at Timber Point, where they raised a family of seven sons and three daughters. At Timber Point, Jake, Mary and the boys would cut firewood for the steamboat that travelled up and down Teslin Lake at the time. Then they'd go down to Brooks Brook, where they also ran a trapline. In late summer there'd be salmon fishing; the family would set nets and catch salmon by the camp at Johnson's Crossing. In the fall they'd have a camp up at 13 Mile on the South Canol Road, where they'd catch groundhogs and pick berries for the winter.

"I'd be guessing what year the photo was taken," Blahitka said. "My mom was born in 1934 and she looks like she's about fourteen or fifteen, so that'd make the photo about 1948, I think. Auntie Dorothy was born about 1932 and Marjorie was born after my mom."

In those days people walked everywhere if they weren't out on the lake. "Sometimes all the way from Tagish to Teslin [a distance of 117 kilometres]," said Blahitka. "If there was a potlatch in Teslin, they'd walk up there to invite people."

In the photographs taken by anthropologists Douglas Leechman and Catharine McClellan, Jake Jackson was in his late sixties and physically fit. In the late spring of 1952, a few weeks before he passed away, he took his daughter Pansy on a walk. Together they rafted some lumber down the Teslin River, then to the end of the family trapline at Canyon Creek to fix the roof on one of the trap cabins. There, Jake told Pansy he wasn't feeling well, so they crossed the river, walked up the hills and came out at Four Mile on the Canol Road, where they caught a ride back to Teslin. Once back, Jake told Pansy he was sick and in quite a bit of pain. He went to bed and never really got up again.

"That's what they'd do, the old-timers," Blahitka said. "They'd do one last big trip if they knew their time was coming, and that's what my grandfather did."

FOR DECADES, EDITH JOSIE (1921–2010) brought the people and daily life of the fly-in Vuntut Gwitchin community of Old Crow, Yukon, to the world. In 1963 she began writing a weekly column, "Here Are the News," which was printed in

the *Whitehorse Daily Star* and soon reached a readership far beyond the territory. She also made appearances on the local radio station, speaking of Gwich'in life and of stories past and present.

"In way back people have a open fire right outside of their house and fry meat and make tea. When people see fire and start to come and start to eat, it was good, that's what people should do together. People have to get together and tell funny story and laugh," she wrote in one column in her distinctive style.

Born in Eagle, Alaska, in 1921 to Paul and Elizabeth Nukon Josie, she moved with her family to Old Crow in the early 1940s. The community, then as now, had a population of around 250. As for formal schooling, Josie completed grades one and two in Eagle, Alaska, but then the teacher left the community. Paul Josie taught ten-year-old Edith how to trap and skin animals and how to stretch and tan skins. The family sold these skins to earn money for food and clothing. In her spare time, her older brother taught her to read and write.

For the next decade, the Josie family traversed the distance between the Whitestone River in the summer for fishing and the village of Old Crow in the winter for hunting and trapping. Eventually, Old Crow became her permanent home, where she raised three children and took care of her aging parents. In 1957 she was appointed Justice of the Peace of Old Crow. But writing became her true passion with the publication of her first columns.

Punctuation, "proper" grammar, and syntax were not Josie's concerns, and thankfully the editors at the *Daily Star* left her writing as it was. Josie wrote in the vernacular that people spoke in Old Crow. Her writing was part of the community, not above it. By the time her first book of columns was published, Josie had received the Canadian Centennial Award and been profiled in *Life* magazine. She would go on to receive the Order of Canada in 1995, a National Aboriginal Achievement Award, and an Indspire Award in 2000.

Technology did not phase her and she easily made the transition from pen and paper to computer in the 1990s, her writing appearing on the community Old Crow website. Her last column appeared in 2005, by which point she was read worldwide.

People are glad that they do every thing come out just like other town so people are glad. They repair some house and look good. For this people are glad. Hope to see caribou in fall time so we could make dry meat. And beside this it was nice to see Air North fly to Old Crow. They bring mail and some passengers travel around. It is nice to fly to Old Crow, Inuvik, Dawson, Fairbanks and fly back to Whitehorse. We have a nice weather sunshine and it is warm weather we have.

Sign off by
Miss Edith Josie

IN 1951, ANTHROPOLOGIST CATHARINE MCCLELLAN, known simply as Katy to many of the locals, took the photo of then fourteen-year-old Emma Alfred holding a beaver foot purse that her mother had just made for her. As Mary Blahitka, who was also a young girl at the time, recalled, "We saw Katy and Julie [Cruickshank] around a lot but didn't think anything of it. We were kids." Both anthropologists, along with Douglas Leechman, were recording legends, histories and other stories from the oral cultures of the Tlingit and Northern Tutchone people.

The land around Pelly Crossing has a deep history. Halfway between Whitehorse and Dawson City, it had long been a trading place where Northern Tutchone and coastal Tlingit would meet and trade, as well as set up fishing camps in the summer. The Hudson's Bay Company built a trading post there, Fort Selkirk, and many of the Tutchone people settled in the area while continuing to trap, hunt, fish and gather in their traditional areas. This area was an active place of trade long before the Klondike gold rush of 1896–99.

Writer Edith Josie (Vuntut Gwitchin).
(Richard Harrington)

Emma Alfred remembers helping her mother sew the beaver foot purse. It had distinctive beaver claws on the front and the word *Yukon* sewn on the sides. The purse was newly finished the day Catharine McClellan took the photograph outside the family tent. "I just came out of swimming, and then my mom told me to hold that purse to take that photo," Alfred recalled.[6] "So there was the proof, right there, that that was my mom's purse."

After that, the purse disappeared. Alfred knew it had been sold, but there was no record of who the buyer was or where it might have ended up. Alfred assumed she would never see it again and that it was in someone's personal collection or a museum, anywhere in the world.

Employed as a support worker for the Selkirk First Nation, Alfred was among a delegation of elders from the Yukon who visited the Canadian Museum of History in Ottawa in 2015, funded by the Yukon Community Development Fund. They were there to identify artifacts from the region and, possibly, begin the act of repatriation that would, one day, bring some of the objects home to be displayed within their nations. As well, they listened to audio recordings from the late 1940s and early 1950s that had been gathered by McClellan, Cruickshank and Leechman. For many of the elders on that trip, it would be a poignant experience, hearing their parents' or grandparents' voices, speaking in their language, for the first time in decades.

The trip to the museum held one more surprise for Alfred. As the elders were shown the artifacts from the region, she saw, for the first time in over sixty years, the purse that she and her mom had lovingly made. "It was quite the sight to see," she recalled. She hopes that, someday, the purse will return to Pelly Crossing.

Emma Alfred (Northern Tutchone), age fourteen, holding a beaver foot purse, Pelly Crossing, Yukon, 1951. (**Catharine McClellan**)

Looking Forward

"When I donated my pictures to the archives, the power of the internet wasn't even envisioned so I had no idea that they would become so accessible."
–JOHN MACFIE

This book has considered, alongside the works of non-Indigenous photographers, the photos of early Indigenous photographers in Canada, including Peter Pitseo-lak, George Johnston and James Jerome. Now, in the early decades of the twenty-first century, there are numerous contemporary Indigenous photographers, in many cases challenging the Western concept of Indigenous peoples—what they look like or where they live—or turning their lenses outward with their gaze on the dominant societal structures. Here are just three examples.

Jeff Thomas (Iroquois), whose work has been shown in exhibitions in Canada and internationally, uses as a starting point the idea of "weaving a new story" of contemporary Indigenous reality. Referencing the work of Edward S. Curtis, Thomas challenges viewers on their image of Indigenous peoples, bringing it from the "wilderness" to a modern, urban environment. His Vanishing Race series of photographs reframes the Curtis trope, using the statues and sculptures of "Indians" in North American cities. As Thomas explains, "My study of Indian-ness seeks to create an image bank of my urban-Iroquois experience, as well as re-contextualize historical images of First Nations people for a contemporary audience."[1]

Bert Crowfoot (Siksika/Saulteaux) has been taking photographs for more than three decades. He has travelled extensively over his career and is well known for both his portraiture and his photographs of Indigenous ceremonies and powwows.

While Crowfoot's photos of ceremonial events are not for sale, many of his photographs of secular events like powwows are commercially available. In 1983, he began publishing *Windspeaker*, a national magazine covering Indigenous issues, and he is also the founder and CEO of the Aboriginal Multi-Media Society of Alberta. He established Alberta's first Indigenous-run radio station, CFWE-FM.

In the last decade of the twentieth century, the inventive photography of Shelly Nero and Lori Blondeau has challenged and overturned the stereotyped images of Indigenous women. Today, Nadya Kwandibens (Anishinaabe) is a young, rising talent in the world of Indigenous photography. After setting up her own studio, Red Works, she built a large social media following with her work and has taken portraits of many contemporary Indigenous artists and activists. Her Concrete Indians project examines the layered dynamics and seeming contradictions of Indigenous identity in Southern, urban centres. "When I first began Red Works, I noticed the total lack of positive imagery of Indigenous peoples. That need for more positive imagery is the basis upon which I create all my work," says Kwandibens.[2]

In researching this book and selecting the photographs, I was conscious that what was being framed were moments in time, and that in most cases the witnesses to the moment were long departed. There is a reward in researching and extracting narratives based on a photo, and a risk that the words will impart some form of closure to the image itself. No narrative can tell the whole story, nor reflect, in all its complexity, a person's life. It is better, I think, to approach the narratives that make up this book as stories inspired by the photographs, not ultimate truths.

Writing this book was akin to assembling a scrapbook, knowing you have a limited number of pages to fill and only a certain quantity of photographers to pull from. As with all history and archival research, there are new photographers and new photographs of the Indigenous experience waiting to be discovered. Somewhere there are boxes of negatives, gathering dust but containing priceless histories. With the tools of research and communication afforded by the Internet and the ability to assemble, digitize and distribute, what is here represents just the beginning. I look forward to the discoveries to come.

In the meantime, if you have experienced some pleasure and learned something from this book, know that your feeling is very much reciprocated by the author.

Acknowledgements

A book like *Blanket Toss Under Midnight Sun* is not possible without the assistance of many people to whom I'm greatly indebted. For graciously giving of their time in interviews, I thank George Annanack, Mary Blahitka, Aggie Brockman, René Fumoleau, John Houston, George Legrady, John Macfie, Antoine Mountain, Gordon Neacappo, Taqralik Partridge, Oliver Rupert, Mary Scriver and Frances Wilkins, among others.

I am indebted to photographers René Fumoleau, George Legrady and John Macfie for sharing their experiences, valuable time and their photos. There are also many at various archives who went beyond the call of duty to track down and make available photographs from their collection; special mentions to Donna Darbyshire at Yukon Archives, Margaret Fireman at the Chisasbi Heritage and Cultural Centre, Kristin Enns-Kavanagh at the Saskatchewan Folklore and History Society, Alexandra Haggert at Library and Archives Canada, Vincent Lafond at the Canadian Museum of History, and Robin Weber at the NWT Archives.

Thank you to Sandra Nabess Macdonald for the invaluable and time-saving transcribing, without which I'd probably still be typing to this day. To Rebecca and Michael Belmore, Lori Blondeau, Wanda Nanibush, Maria Campbell, Morningstar Mercredi, Eden Robinson, Erica Violet Lee, Chelsea Vowel, Jesse Wente and so many others who may not know it, but inspire me every day. In working on this

book, I've been inspired by the Indigenous photographers who are framing the contemporary Indigenous experience, worldwide. Your work, in galleries and online, is one of resilience, beauty and strength. You amaze me.

Thank you to Amanda Lewis for being both a sensitive and a meticulous editor. Thanks to Lynn Henry, Jennifer Lum, Rick Meier and the gang at Knopf Canada for believing in this project and the care with which they've treated the photographs and the narrative.

Thanks to my redoubtable agent Denise Bukowksi for taking care of the icky stuff like contracts and rights and making a writer's life a lot easier.

To my two children, Suriya and Coltrane: Thank you for putting up with my prolonged absences and distractions. May you both follow your dreams of writing and the arts. It can be a perilous existence but ultimately a very rewarding one.

Finally, all errors or omissions in this book are mine and mine alone. I hope they are outweighed by the truths and beauty within. And to all the others who have followed this project on social media and offered comments, encouragement, names and stories: Without you this book would not exist. I thank you.

Hiy hiy.

Endnotes

INTRODUCTION

1. Tlakatekatl, "The Problem with Indigeneity," https://mexika.org, September 17, 2014.

CAPE DORSET (KINNGAIT)

1. Jean Blodgett, *Kenojuak* (Toronto: Firefly Books, 1985).

2. Rosemary (Gilliat) Eaton papers, Library and Archives Canada.

3. Kananginak Pootoogook, *Cape Dorset Prints* (Cape Dorset: West Baffin Eskimo Co-Operative, 1973).

NUNAVIK

1. "Trauma Flowing from Nunavik Dog Slaughters Slow to Heal," Sarah Rogers, *Nunatsiaq News*, August 9, 2011.

2. Legal representative of Quebec's Inuit, established in 1978.

3. CBC News, "Okpik's Dream, Nunavut dog sled documentary, wins award," CBC.ca, August 12, 2015, http://www.cbc.ca/news/canada/north/okpik-s-dream-nunavik-dog-sled-documentary-wins-award-1.3188115.

4. Ibid.

5. Unlike an igloo, which is constructed out of blocks of ice, a snow house, or quinzee, is hollowed out from a large mound of snow.

JAMES BAY

1. Marika Wheeler, "Bringing traditional midwives back to Cree communities in Quebec," CBC.ca, March 25, 2017, http://www.cbc.ca/news/canada/montreal/midwives-quebec-north-salluit-maternity-indigenous-1.4040828.

2. Billy Diamond, *In His Own Words* (Crees of Waskaganish First Nation, 2017).

3. As part of a documentary photography project in the James Bay region in the early 1970s.

4. Frances Wilkins, *The Fiddlers of James Bay: Transatlantic Flows and Musical Indigenization among the James Bay Cree* (2015).

HUDSON BAY

1. John Macfie and Basil Johnston, *Hudson Bay Watershed* (Toronto: Dundurn Press, 1991).

SASKATCHEWAN

1. James Daschuk, *Clearing the Plains: Disease, Politics of Starvation, and the Loss of Aboriginal Life* (Regina: University of Regina Press, 2016).

2. Non-Indigenous civilians who hunted prairie wolves to collect government-paid bounties.

3. Whoop-Up Bug Juice was one of the alcohols sold at the Fort, spiked with ginger, molasses and red pepper. It was then coloured with black chewing tobacco and watered down and boiled to make "firewater."

4. "An Act to Amend the Indian Act," Indian and Northern Affairs Canada, *Indian Acts and Amendments, 1868–1950* (Ottawa: DIAND).

5. Presented with an item, such as food or clothing, in a sign of respect for the person.

MONTANA AND ALBERTA

1. Bill Heavy Runner, Blood Reserve, University of Regina oral transcripts, 1977.

2. Isaac I. Stevens papers, 1831–92, Archives West.

3. Correspondence with Mary Scriver, September 16, 2017.

4. John L. Steckley, *Indian Agents: Rulers of the Reserves* (New York: Peter Lang Publishing, 2016).

5. It is not known why she waited ten years to come forward.

6. "Massacre of Piegan in 1870," *Billings Gazette*, 1932.

7. Hired by the BIA (Bureau of Indian Affairs) in 1941 to help design the Museum of the Plains Indian.

8. Plains Indigenous narrative drawing or painting on paper or cloth, often drawn on ledger paper.

9. Conversation with Mary Scriver, July 25, 2017.

10. Conversation with Mary Scriver, July 20, 2017.

11. Adolf Hungry Wolf, *The Blackfoot Papers*, vol. 1 (Good Medicine Cultural Foundation, 2006), p. 265.

12. Ibid.

13. Ibid., p. 275.

NORTHWEST TERRITORIES

1. Daniel Campbell, "The hero of the Dene," *Up Here* (magazine), April 1, 2015.

2. Dianne Meili, "George Blondin: Footprints," *Windspeaker* (magazine), 2008.

3. René Fumoleau, *Denedeh: A Dene Celebration* (Dene Nation, 1984).

4. The surname Norwegian is said to derive from a member of John Franklin's expedition, who in the 1820s abandoned the doomed expedition and settled and married into the local Dene community.

5. The first Northwest Territories mission school opened in 1867 at Fort Providence.

6. June Helm (1924–2004) was an American anthropologist and amateur photographer, noted for her fieldwork and writings on the Dene of the Mackenzie Valley.

7. *Decho Visions* (December 2006). Published posthumously, based on recorded interviews with Paul Wright.

YUKON TERRITORY

1. Thomas F. Thornton, *Patsy Henderson's Story* (Ottawa: Klondike Gold Rush National Historical Park, 2004).

2. Dawson Charlie, George and Kate Carmack, Robert Henderson and Skookum Jim, "People of the Yukon" (Yukon Tourism and Culture Archives, 2017).

3. Catharine McClellan, *My Old People's Stories: A Legacy for Yukon First Nations*, Part III: Inland Tlingit Narrators (Yukon Tourism and Culture, 2010).

4. Angela Sidney and Julie Cruickshank, *Haa Shagoon: Our Family History* (Yukon Native Languages Project, 1983).

5. Angela Sidney, *My Stories Are My Wealth* (Whitehorse: Willow Printers, 1977).

6. CBC News, "Yukon elder discovers mother's purse at national museum," CBC.ca, March 27, 2015, http://www.cbc.ca/news/canada/north/yukon-elder-discovers-mother-s-purse-at-national-museum-1.3011050.

EPILOGUE: LOOKING FORWARD

1. Artist statement: Jeff Thomas, Photo-based Artist and Independent Curator.

2. CBC Radio, *Unreserved*, December 13, 2016.

Photo Credits

PAGE i; PAGE 182
"Blanket Toss Under Midnight Sun" © Steve McCutcheon, McCutcheon Collection; Anchorage Museum, B1990.014.5.AKNative.22.7. Reproduced with permission.

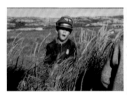

PAGE ii–iii; PAGE 52
"Young boy wearing a hat with a large brim" © Library and Archives Canada. Reproduced with the permission of Library and Archives Canada. Source: Library and Archives Canada/ Rosemary Gilliat Eaton fonds/ e010799950.

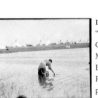

PAGE vi–vii
"Woman in lake (Water Carrier)" © Walter McClintock, Beinecke Rare Book and Manuscript Library Repository. Used with permission.

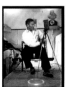

PAGE x
"Peter Pitseolak with 2222 camera photographer Aggeok Pitseolak" © Canadian Museum of History 2000-189.

PAGE 6
"Woman (possibly Rosemary Gilliat Eaton) wearing a winter coat with a fur-trimmed hood and using photographic equipment to make images of frost on the windows. Shilly Shally Lodge, Gatineau Park" © Library and Archives Canada. Reproduced with the permission of Library and Archives Canada. Source: Library and Archives Canada/ Rosemary Gilliat Eaton fonds/ R12438-1793-0-E.

PAGE 7
"James Jerome" © NWT Archives/James Jerome fonds/N-1987-017: 1446.

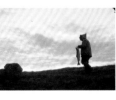

PAGE 8–9
"Man walking on a slope carrying a fish" © Library and Archives Canada. Reproduced with the permission of Library and Archives Canada. Source: Library and Archives Canada/ Rosemary Gilliat Eaton fonds/ e010799924.

PAGE 10
"Artist Kiakshuk drawing in a tent, Cape Dorset, Nunavut" © Library and Archives Canada. Reproduced with the permission of Library and Archives Canada. Source: Library and Archives Canada/Rosemary Gilliat Eaton fonds/e010975354.

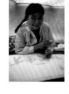

PAGE 21
"Artist Kenojuak drawing inside her tent, Cape Dorset, Nunavut" © Library and Archives Canada. Reproduced with the permission of Library and Archives Canada. Source: Library and Archives Canada/Rosemary Gilliat Eaton fonds/e010835887.

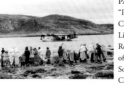

PAGE 13
"People watching a plane arrive, Cape Dorset, Nunavut" © Library and Archives Canada. Reproduced with the permission of Library and Archives Canada. Source: Library and Archives Canada/Rosemary Gilliat Eaton fonds/e010835984.

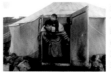

PAGE 22
"Artist Kenojuak carrying an infant on her back and exiting a tent, Cape Dorset, Nunavut" © Library and Archives Canada. Reproduced with the permission of Library and Archives Canada. Source: Library and Archives Canada/Rosemary Gilliat Eaton fonds/e010835916.

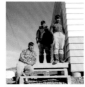

PAGE 14
"Three printmakers outside the Cape Dorset Craft Centre, Cape Dorset, N.W.T." © Library and Archives Canada. Reproduced with the permission of Library and Archives Canada. Source: Library and Archives Canada/Rosemary Gilliat Eaton fonds/e010767684.

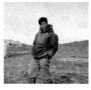

PAGE 25
"Kananginak Pootoogook, president of the West Baffin Co-operative, Cape Dorset, Nunavut" © Library and Archives Canada. Reproduced with the permission of Library and Archives Canada. Source: Library and Archives Canada/Rosemary Gilliat Eaton fonds/e010767681.

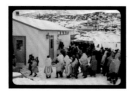

PAGE 16–17
"Opening of the West Baffin Co-operative" © Terrence Ryan/Library and Archives Canada. Reproduced with the permission of Library and Archives Canada. Source: Library and Archives Canada/Rosemary Gilliat Eaton fonds/e010799833.

PAGE 26
"Two men, one in middle is Kananginak Pootoogook, and a woman return from fishing, Cape Dorset, Nunavut" © Library and Archives Canada. Reproduced with the permission of Library and Archives Canada. Source: Library and Archives Canada/Rosemary Gilliat Eaton fonds/e010975410.

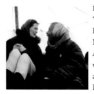

PAGE 18
"Alma Houston and Kingwatsiak, Cape Dorset, Nunavut" © Library and Archives Canada. Reproduced with the permission of Library and Archives Canada. Source: Library and Archives Canada/Rosemary Gilliat Eaton fonds/e010975350.

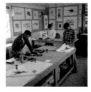

PAGE 29
"Inuit printmakers at work in the Art Centre, Cape Dorset, N.W.T." Public Domain. Source: Library and Archives Canada/National Film Board fonds/e011177385.

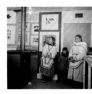

PAGE 30
"Sheouak Petaulassie (left), her boy and a friend during a visit at the West Baffin Co-operative, Cape Dorset, Nunavut" © Libraries and Archives Canada. Reproduced with permission of Libraries and Archives Canada. Source: Library and Archives Canada/ Rosemary Gilliat Eaton fonds/ R12438-2524-0-E.

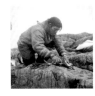

PAGE 43
"Stanley Annanack gutting freshly-caught Arctic char, Kangiqsualujjuaq, Quebec" © Library and Archives Canada. Reproduced with the permission of Library and Archives Canada. Source: Library and Archives Canada/Rosemary Gilliat Eaton fonds/e010975384.

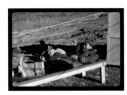

PAGE 33
"Man napping on an outdoor bench" © Library and Archives Canada. Reproduced with the permission of Library and Archives Canada. Source: Library and Archives Canada/Rosemary Gilliat Eaton fonds/e010800012.

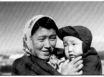

PAGE 45
"Young woman holding a little boy, Kuujjuaq, Quebec" © Library and Archives Canada. Reproduced with the permission of Library and Archives Canada. Source: Library and Archives Canada/Rosemary Gilliat Eaton fonds/ e010799808.

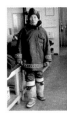

PAGE 35
"Peter Pitseolak in the textile shop" © Library and Archives Canada. Reproduced with the permission of Library and Archives Canada. Source: Library and Archives Canada/ Charles Gimpel fonds/ e004922708.

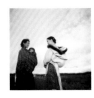

PAGE 46
"Imaapik Jacob Partridge (right) and an unidentified man seated on a mattress in a tent" © Library and Archives Canada. Reproduced with the permission of Library and Archives Canada. Source: Library and Archives Canada/Rosemary Gilliat Eaton fonds/e010868908.

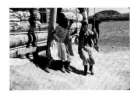

PAGE 36; PAGE 179
"Three girls playing on a swing" © Library and Archives Canada. Reproduced with the permission of Library and Archives Canada. Source: Library and Archives Canada/Rosemary Gilliat Eaton fonds/e010799915.

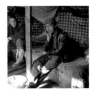

PAGE 49
"Two Inuit women with their babies in their amautis (parkas), Kuujjuaq Quebec." Public Domain. Source: Library and Archives Canada/National Film Board of Canada fonds/ e010955827.

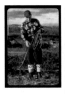

PAGE 40
"George Koneak gathering up rope" © Library and Archives Canada. Reproduced with the permission of Library and Archives Canada. Source: Library and Archives Canada/ Rosemary Gilliat Eaton fonds/ e010835931.

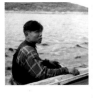

PAGE 50
"Inuit man, [Johnny Makalu (Morgan)] in a kayak, Kangiqsualujjuaq, Quebec" © Library and Archives Canada. Reproduced with the permission of Library and Archives Canada. Source: Library and Archives Canada/Rosemary Gilliat Eaton fonds/e010975439.

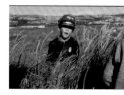

PAGE 52
See credit for page i.

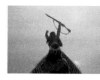

PAGE 66–67
"Hunting in Eastmain [Summer, 1973], two young men in canoe, one holding gun up in air" © George Legrady, 1973, 2013, 2018 Used by permission.

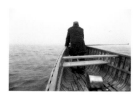

PAGE 54–55
"Man standing at the front of a canoe in the water" © George Legrady, 1973, 2013, 2018 Used by permission.

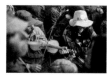

PAGE 69
"Triple Wedding, June 21, 1973. A fiddler, Bobby Georgekish and Evadney Kakabat (Woman with hat and wife of Billy Kakabat who was playing guitar at the dance) at the Harry Asquabaneskum, Michael Mayappo, Johnny Natawpineskum, Daniel Ratt wedding dance party" © George Legrady, 1973, 2013, 2018 Used by permission.

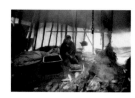

PAGE 56; PAGE 71
"Nettie Blackboy sitting on the floor inside a michiiwaahp (tipi) near a fire" © George Legrady, 1973, 2013, 2018 Used by permission.

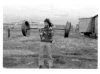

PAGE 73
"Visiting Fort George [Summer, 1973], George Legrady, photographer, lifting weights" © George Legrady, 1973, 2013, 2018 Used by permission.

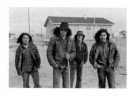

PAGE 60
"Group of four young men [Fort George, Summer 1973], Michael Sam, Oliver Rupert lead guitarist of Fort George Rockers (with the stick), Elmer Sam, Samuel House" © George Legrady, 1973, 2013, 2018 Used by permission.

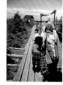

PAGE 74
"Child in a tikinagun, Lansdowne House, 1956." Photo: John Macfie © Archives of Ontario. Source: C 330-14-0-0-63, Archives of Ontario.

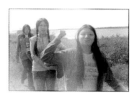

PAGE 62–63
"Visiting Eastmain [Quebec, Summer of 1973], Laura Moses, Josephine Mayappo, and Beatrice Gilpin walking by the river" © George Legrady, 1973, 2013, 2018 Used by permission.

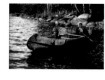

PAGE 78–79
"Maria Mikenak and grandson in a canoe, Lake St. Joseph, 1956." Photo: John Macfie © Archives of Ontario. Source: C 330-14-0-0-1, Archives of Ontario.

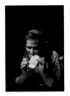

PAGE 80
"William Moore making 'bitten bark' design, 1958." Photo: John Macfie © Archives of Ontario. Source: C 330-14-0-0-121a, Archives of Ontario.

PAGE 90–91, PAGE 124–125
"Strikes in the Night gathering strawberries." © Walter McClintock, Beinecke Rare Book and Manuscript Library Repository. Used with permission.

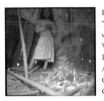

PAGE 83
"Smoking moosehide inside wigwam-shaped smokehouse - Weagamow Lake, 1955." Photo: John Macfie © Archives of Ontario. Source: C 330-13-0-0-138, Archives of Ontario.

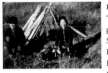

PAGE 92; PAGE 179
"Two children (Cree) with puppies, Loon Lake, Saskatchewan, 1943." Photo: Everett Baker © Saskatchewan History & Folklore Society. Used with permission.

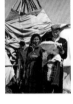

PAGE 84
"Postcard of the Suguanaqueb family at Neskantaga, 1956" © John Macfie. Reproduced by permission of John Macfie.

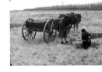

PAGE 96
"Cree women digging clay, Duck Lake, Saskatchewan, 1944." Photo: Everett Baker © Saskatchewan History & Folklore Society. Used with permission.

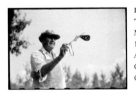

PAGE 86
"A 'nabahon' made by William Moore of Mattagami Reserve, 1957." Photo: John Macfie © Archives of Ontario. Source: C 330-13-0-0-1, Archives of Ontario.

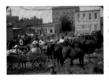

PAGE 99
"The day after the fair (Cree/Dakota/Métis), North Battleford, Saskatchewan, 1945." Photo: Everett Baker © Saskatchewan History & Folklore Society. Used with permission.

PAGE 89
"Photographer John Macfie dancing with Sally Miles at Fort Severn." Photo: George Arthor. Public Domain.

PAGE 100
"St. Laurent pilgrimage. (Cree/Métis). Near Duck Lake. 1944." Photo: Everett Baker © Saskatchewan History & Folklore Society. Used with permission.

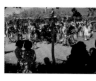

PAGE 103

"Dakota powwow, Fort Qu'appelle, Saskatchewan, 1957." Photo: Everett Baker © Saskatchewan History & Folklore Society. Used with permission.

PAGE 117

"A Blackfeet man wearing white coveralls, leaning against a brick building with decorative iron work [c. 1942]." Photo: Thomas B. and Henry L. Magee. Image courtesy of the Bruce Peel Special Collections, University of Alberta.

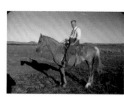

PAGE 104–105

"Everett Baker on horseback, Val Marie, Saskatchewan, 1957." Photo: Unknown. © Saskatchewan History & Folklore Society. Used with permission

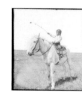

PAGE 118

"Tom Magee, chickens and dogs [Montana, c. 1912] © Walter McClintock, Beinecke Rare Book and Manuscript Library Repository. Used with permission.

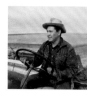

PAGE 106

"Dusty Bull's son on horseback, c. 1903" © Walter McClintock, Beinecke Rare Book and Manuscript Library Repository. Used with permission.

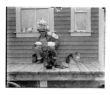

PAGE 118

Photo of Henry Magee, *The Blackfoot Papers*, Adolf Hungry-Wolf, ed. 2006.

PAGE 111

"Man wearing denim driving a tractor [Cecil John Crowfoot from the Siksika Nation, Alberta]" © Library and Archives Canada. Reproduced with the permission of Library and Archives Canada. Source: Library and Archives Canada/Rosemary Gilliat Eaton fonds/e010975124.

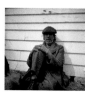

PAGE 121

"Tom Spotted Eagle [(Siksika), Montana, c. 1930]." Photo: Thomas Magee. Image courtesy of the Bruce Peel Special Collections, University of Alberta.

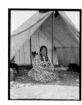

PAGE 114

"Good Spear Woman [Montana, c. 1908]" © Walter McClintock, Beinecke Rare Book and Manuscript Library Repository. Used with permission.

PAGE 124–125

See credit for page 90–91.

PAGE 126–127
"Fort Good Hope 02-69
– Girls–Rita Kakfwi, Ruth
Kakfwi–'I Was Born Here'
Photo: René Fumoleau © NWT
Archives/René Fumoleau
fonds/N-1995-002: 0032.
Used by permission.

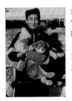

PAGE 139
"Paul Wright (Sahtu) with a
handful of puppies, NWT, c.
1955" © Rev. Bernard Brown.
Image courtesy of the Canadian
Museum of History.

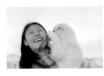

PAGE 128
"Fort Good Hope 02-69–Elder–
Gabriel Kakfwi" © NWT
Archives/René Fumoleau fonds/
N-1995-002: 0053. Used by
permission.

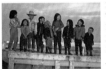

PAGE 141
"Julie-Ann Andre cuts a fish
on a work table under a covered
drying stage. She is at her parents
Gabe and Rosa's fish camp
at Tr'ineht'ieet'iee on the
Mackenzie River." © NWT
Archives/James Jerome
fonds/N-1987-017: 1446.
Used by permission.

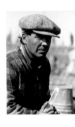

PAGE 132
"Dettah–04-71 Dog–
Mary Jane Martin" © NWT
Archives/René Fumoleau
fonds/N-1998-051: 0611.
Used by permission.

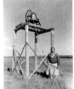

PAGE 144–145
"Deline 05-68–Children–
Bernice Taneton, Goldie
Modeste, Patricia Takazo,
Paul Kodakin, Lucy Ann Kenny,
Anne Marie Bezha, Carolina
Kenny, Steven Taneton, Leonard
Kenny." © NWT Archives/René
Fumoleau fonds/
N-1995-002: 0702.
Used by permission.

PAGE 135
"JMR [Jean Marie River] 1952.
Helm #79, Ch. 18, p. 752.
[Louis Norwegian at age forty-
five, Jean Marie River, 1952.
Caption taken from The People
of Denendeh: Ethnohistory of
the Indians of Canada's
Northwest Territories, by June
Helm, page 359.]" Photo: June
Helm © NWT Archives/June
Helm fonds/N-2003-037: 0225.
Used by permission.

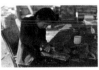

PAGE 146
"A First Nations woman ringing
a large bell on a wooden scaffold
[1946]." Photo: Claude Tidd
© Yukon Archive, Claude and
Mary Tidd fonds, 77/19, #8250.
Used by permission.

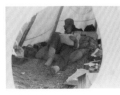

PAGE 136
"Antoine Mountain sketching"
(Dene), Sans Sault Rapids,
NWT 1980." Photo: René
Fumoleau © NWT
Archives/René Fumoleau
fonds/N-1995-002: 8205.
Used by permission.

PAGE 151
"Angela Sidney, Tagish woman,
Carcross, Yukon, Catharine
McClellan, 1951" © Canadian
Museum of History, S71-909.

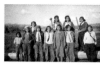

PAGE 154–155
"Girls baseball team (Tlingit),
Nisutlin River, Yukon, 1941."
Photo: George Johnston
© Yukon Archives, George
Johnston fonds, 82/428, #33.
Used by permission.

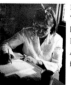

PAGE 160
"Edith Josie, Old Crow writing
her newspaper column." Photo:
Richard Harrington © Yukon
Archives, Richard Harrington
fonds, 85/25, #337.

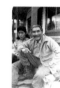

PAGE 157
"Jake Jackson and his daughter,
Teslin, Yukon, Douglas
Leechman, 1948" © Canadian
Museum of History, J2268.

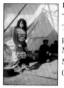

PAGE 163
"Emma Alfred, Northern
Tutchone girl with beaver
purse (VI-Q-47), Catharine
McClellan, c. 1966" © Canadian
Museum of History, IMG2015-
0055-001-Dm.

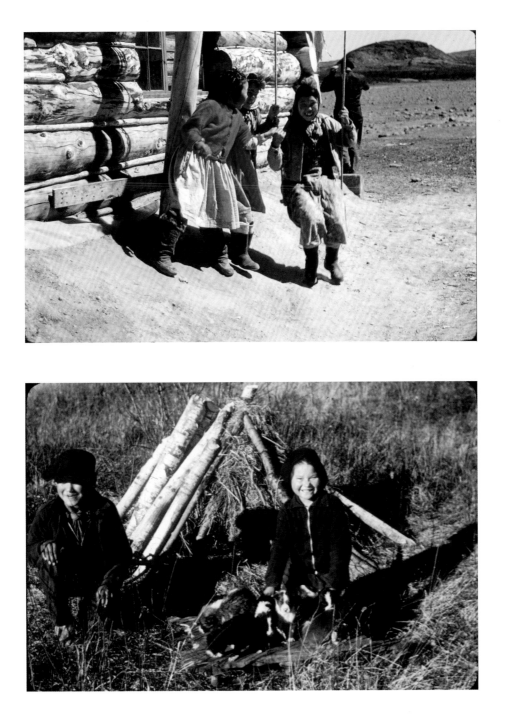

PAUL SEESEQUASIS is a nîpisîhkopâwiyiniw (Willow Cree) writer, journalist, cultural advocate and commentator currently residing in Saskatoon, Saskatchewan. Since 2015, he has curated the Indigenous Archival Photo Project, an online and physical exhibition of archival Indigenous photographs, that explores history, identity and the process of visual reclamation. His writings have appeared in *The Globe and Mail*, *The Walrus*, *Brick*, and *Granta* magazines, among others. He has been active in the Indigenous arts, both as an artist and a policy maker, since the 1990s.

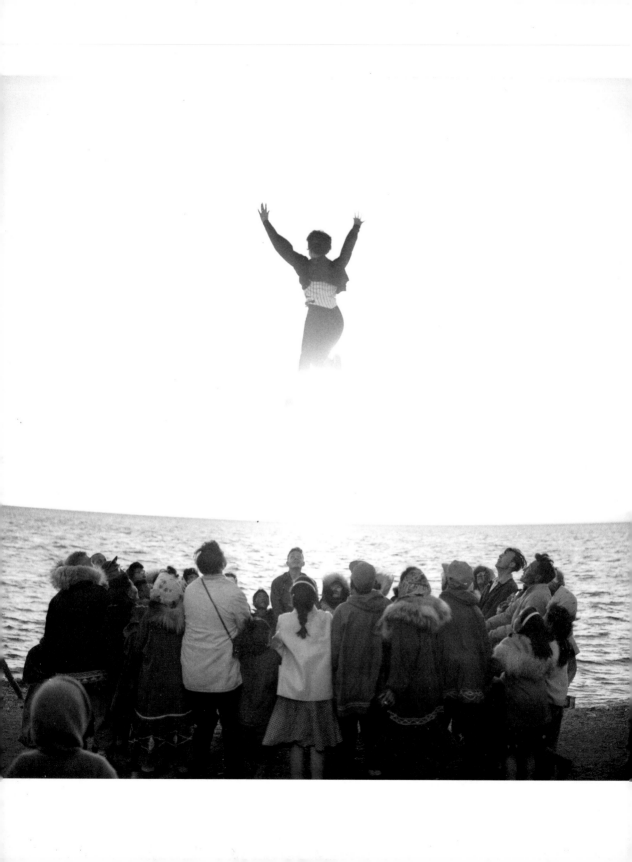